Fred Williams
An Australian Vision

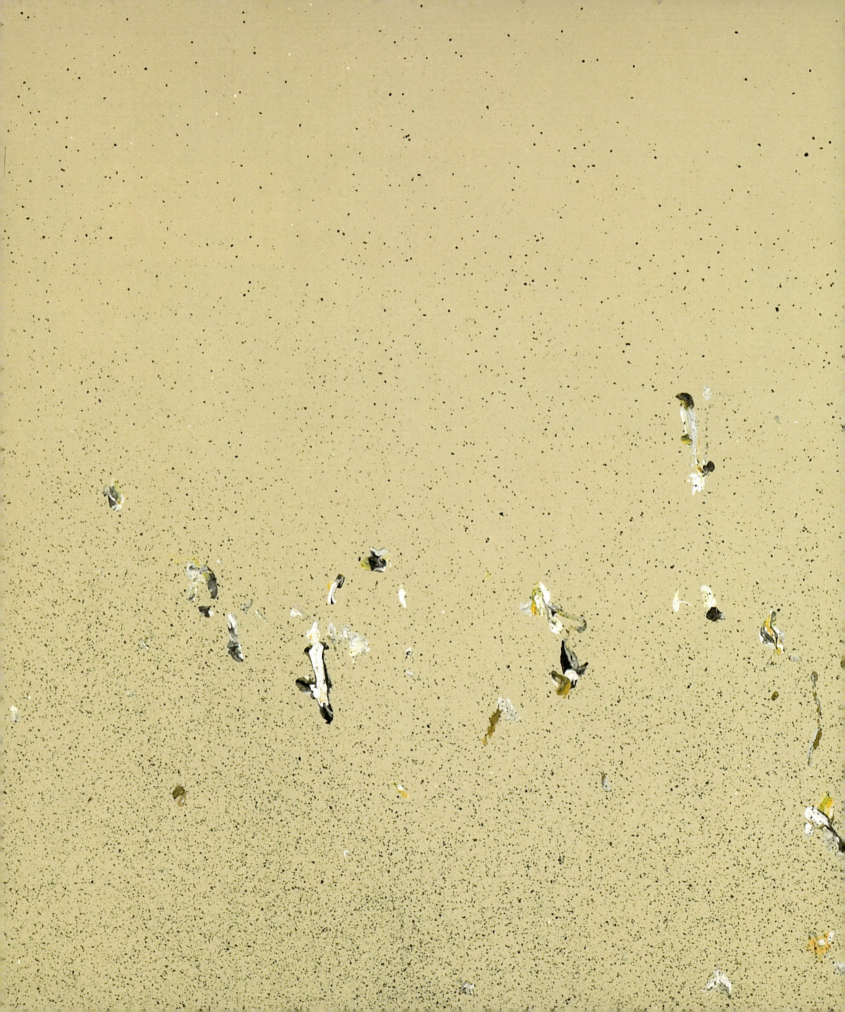

Fred Williams
An Australian Vision

Irena Zdanowicz

Stephen Coppel

THE BRITISH MUSEUM PRESS

**The Trustees of the British Museum gratefully acknowledge the
generous support of News International Limited**

Our foremost debt is to Lyn Williams for her magnificent gift to the British
Museum and for her constant support and counsel in the preparation of the
catalogue and the exhibition. We should also like to thank Roger Butler, Frances
Carey, Rod Clarke, Neil Clerehan, Sonia Dean, Erwin Fabian, Jennifer Fellinger,
Teresa Francis, Ted Gott, Kirsty Grant, Antony Griffiths, Gerard Hayes, Des
Katsakis, Cathy Leahy, John Loane, John and Felicity Mallet, Helen Maudsley,
Steven Miller, James Mollison AO, Lisa Moore, Daniel Moynihan, John Neeson,
John Payne, John Robinson, Julie Robinson, Dana Rowan, Anne Ryan, Susan
Shaw, Dawn Spiers, Margaret Stones, Susan Walby and Michael Watson.
Thanks are also due to the National Gallery of Victoria, Melbourne, for its
support of this project.

All the works by Fred Williams are reproduced with permission © Estate of
Fred Williams. Extracts from the Diary are quoted with permission © Estate of
Fred Williams.

We are grateful to John Williams and Kevin Lovelock, Department of
Photography and Imaging, for the digital photography of works in the British
Museum's collection, and to John Baily, John Brash, Predrag Cancar, Katie
Dobson, Helen Skuse, Garry Sommerfeld, Fiona McDougall, Jennie Moloney,
the late David Moore and Christopher Webster for kindly facilitating the
photography of works by Williams not held by the British Museum and for
providing documentary photographs.

First published in 2003 by The British Museum Press
A division of The British Museum Company Ltd
46 Bloomsbury Street, London WC1B 3QQ

ISBN 0-7141-2639-X

Editorial Direction	Roger Sears
Art Direction	David Pocknell
Editor	Johanna Stephenson
Layout and typesetting	Harry Pocknell
Printed in Spain by Grafos	

Previous pages:
Australian Landscape No.10, 1969 [Cat. 87, p. 96] (detail)

Opposite:
Fred Williams in his studio, wiping an etching plate, March 1969,
photograph by David Moore ©

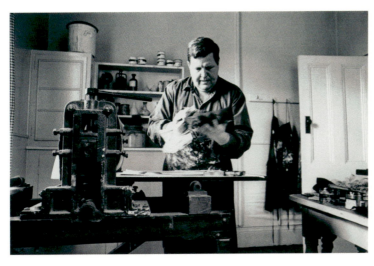

Contents

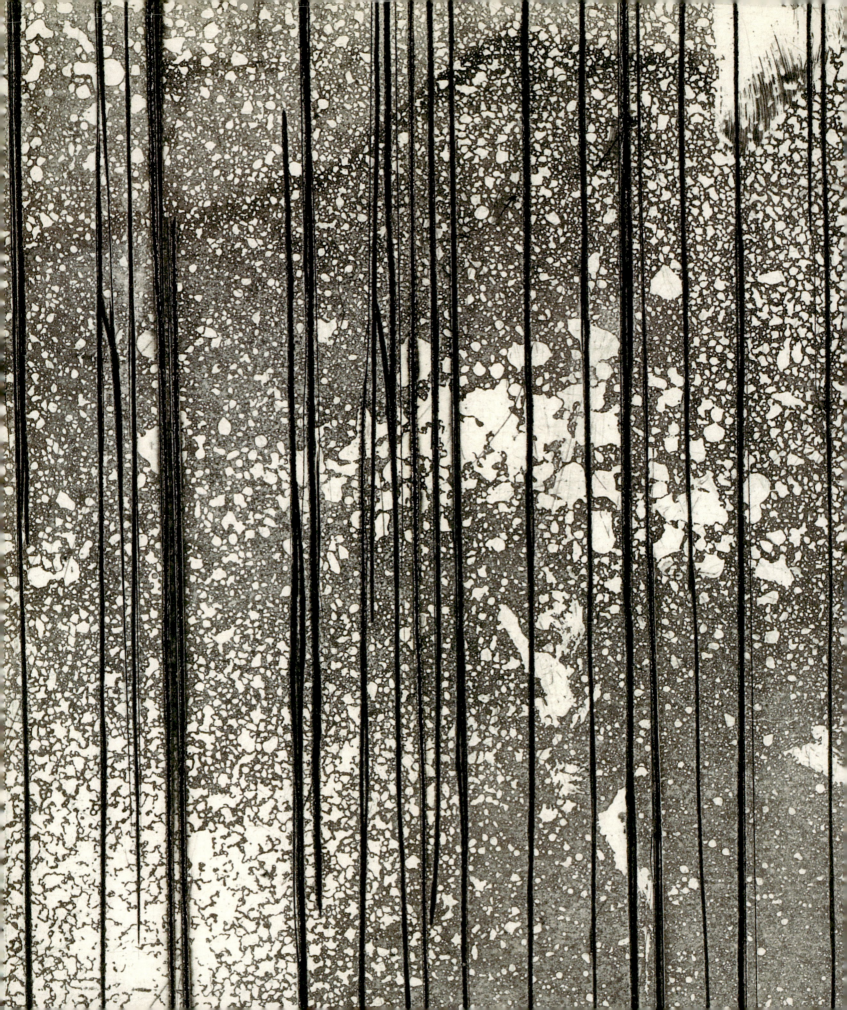

Preface

Neil MacGregor - Director of the British Museum

Sapling Forest, 1961 [Cat. 27, p. 70] (detail)

It is just over twenty years since the Australian painter and etcher Fred Williams died in 1982 at the age of 55, depriving Australia of arguably its most important landscape artist since the Second World War. A household name in his native country, Williams is represented in all the major public collections there, notably the National Gallery of Australia, Canberra and the National Gallery of Victoria, Melbourne. He has been the subject of two pioneering monographs, both written by distinguished former museum directors: James Mollison's *A Singular Vision: The Art of Fred Williams* (1989), and Patrick McCaughey's *Fred Williams 1927–1982*, first published under the title *Fred Williams* in 1980 and now in its third revised edition. Williams has also been the subject of many museum exhibitions in Australia, most comprehensively the retrospective of 400 works held at the National Gallery of Australia in 1987.

In the United Kingdom, by contrast, Fred Williams has remained little known, despite the inclusion of his work in the groundbreaking exhibition *Recent Australian Painting* at the Whitechapel Gallery in 1961, and more recently a solo show of his late landscapes at the Serpentine Gallery in 1988. Yet this country played an important part in the development of Williams's career, for it was during the five years he spent in London in the 1950s that he learnt to etch at the Central School and went on to study at first hand the rich collection of Rembrandt and Goya etchings in the British Museum's Print Room. The present exhibition is entirely due to the outstanding generosity of the artist's widow, Lyn Williams, who has recently presented some seventy etchings and nine major drawings, gouaches and watercolours to the British Museum's Department of Prints and Drawings. This astonishing gift ranges from his first etchings on the theme of the London music hall to the development of his personal vision of the Australian landscape that began on his return to Melbourne in 1957. I believe that Fred Williams would be pleased to know that his works will now join Rembrandt and Goya in the Print Room of the British Museum, to be studied and enjoyed by all those who, like him, come here to look at great art at close quarters.

Williams's vision of the landscape is one recognized and related to by all Australians and indeed all new arrivals – the absence of the picturesque and of any focal point, the overall scrubby monotony, the boundless sense of space and open expanse. To express this very non-European visual experience, Williams devised his own formal language of mark-making and spatial configurations which he explored simultaneously in his painting and his printmaking. How this developed is lucidly and beautifully explained in the essay written by Irena Zdanowicz.

I am deeply grateful to Lyn Williams for her magnanimous gift and for her close involvement in this project. I should also like to thank Irena Zdanowicz, formerly Senior Curator of Prints and Drawings at the National Gallery of Victoria, Melbourne, for her scholarly essay and Stephen Coppel, Assistant Keeper in the British Museum's Department of Prints and Drawings, for making the selection of the gift from the artist's estate and for overseeing this exhibition and publication. I should also like to thank James Mollison AO for donating four rare states of etchings to complement those in Lyn Williams's gift. Finally, I am most grateful to News International Limited for the sponsorship of this landmark exhibition and handsome catalogue.

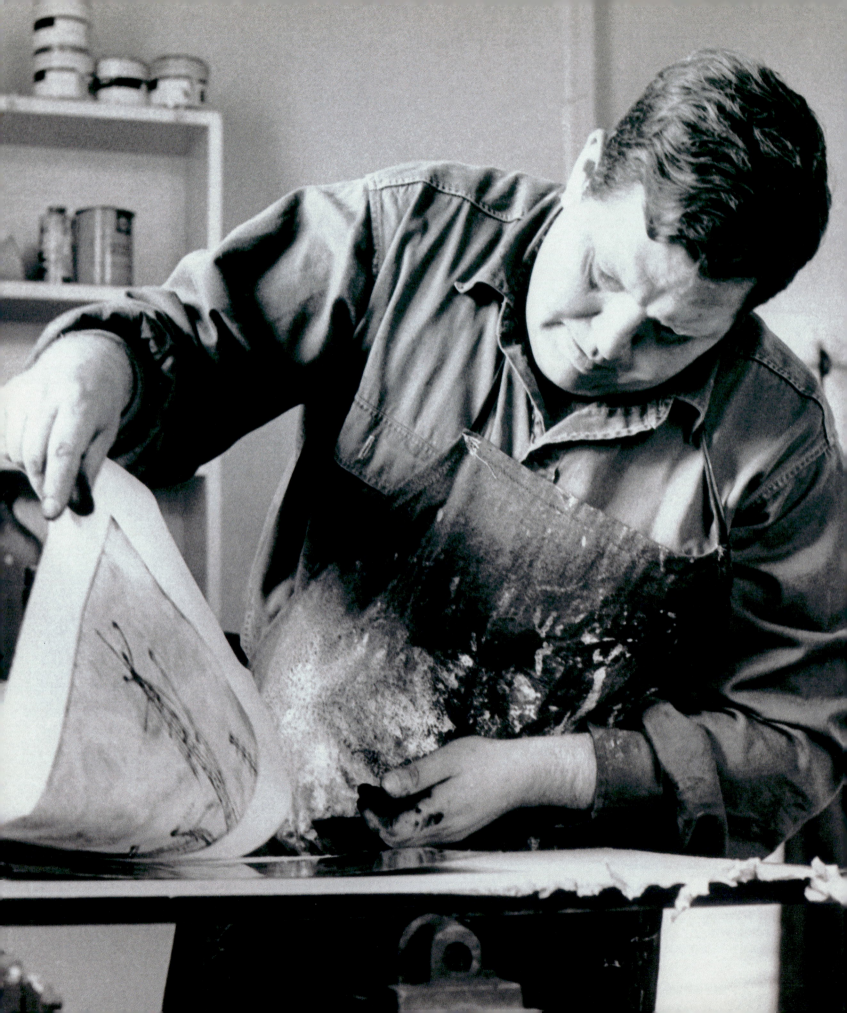

Fred Williams

Irena Zdanowicz

Fred Williams pulling a proof at his printing press, March 1969, photograph by David Moore © (detail)

In 1956, after five years' work and study in London, Fred Williams made the decision to return home to Australia. He had no clear idea of how, once he had returned, he would pursue a career as an artist, but he was in no doubt of his need to keep painting and drawing and, as he had learned to do in London, to make etchings.

Williams's first glimpse of Australia on the return voyage came at Fremantle, Western Australia, where his ship made landfall in late December 1956, a month before his thirtieth birthday. It was here – on the other side of the continent from his home town, Melbourne – that Fred Williams, seeing the Australian summer landscape with fresh eyes, was struck by its 'peculiarity'[1] and he determined in that instant to paint it. As he later recalled, the idea became an obsession.[2] On reaching Melbourne he was asked by his close friend, the artist John Brack (1920–1999), about his intentions and Williams expressed his decision somewhat differently, telling Brack that he was 'going to paint the gum tree'. Brack, sceptical, protested: 'You can't do that. Everybody's done that', to which Williams replied '[w]ell it's just what I'm going to do.'[3] Although he might not have realized it at that moment, Williams was setting himself a bold artistic challenge. Since the beginning of European settlement, Australian art had been dominated by landscape painting and by the need to find a meaningful artistic form for a new and unfamiliar geography and vegetation. It was this tradition that Williams was, in effect, taking on.

His abrupt and unambiguous decision initially surprised no one more than the artist himself. His early studies at art school and virtually all of his subsequent painting had been devoted to the human figure, and, even in later years, Williams lost little of his sense of surprise at this sudden change of direction.[4] Although he continued to paint other subjects after his return to Australia – he produced, for example, portraits and still lifes – it was the Australian landscape that dominated his art. His vision of that landscape was ultimately to become so powerful that it flowed back from the representation to the subject itself: he devised new ways of depicting the landscape and, in doing so, new ways in which it would be seen.

The Early Years in Melbourne (1943–1951)

Fred Williams never doubted his vocation. He always wanted to be an artist, despite his father's reluctance to accept his choice of profession. He was born on 23 January 1927 in Richmond, a working-class suburb of Melbourne, the younger of two children. His father, who was an electrical engineer, would have much preferred him to be an architect, but deferred to the opinion of the family doctor, Clive Stephen (1889–1957), who was himself a gifted amateur artist. Stephen's encouragement facilitated Williams's decision and, in late 1943, aged sixteen, he enrolled in night classes at the National Gallery School. To support himself and to please his father he took up an apprenticeship with a firm of shopfitters, where he worked in the drafting office. Doing so enabled him to earn his living, but it was neither the right occupation nor the right milieu for him. These he found at the National Gallery of Victoria Art School, where he quickly made friends and embraced his art education wholeheartedly.

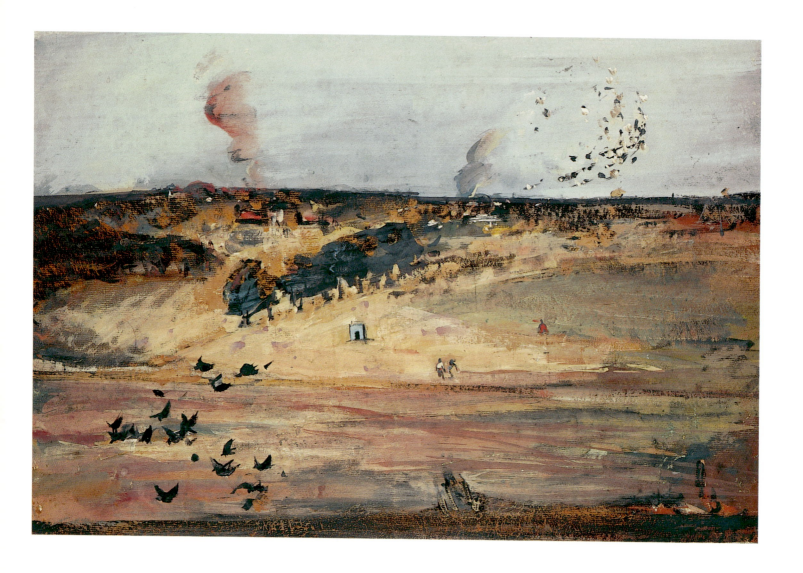

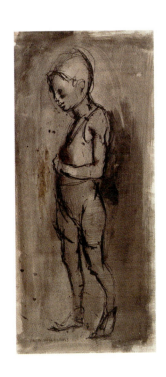

Above: fig. 1 **Figure of a Boy**, c.1949, pen and ink, brush and crimson ink, pink and grey washes on paper, 341 x 167 mm (Melbourne, National Gallery of Victoria, purchased 1949)

Opposite: fig. 2 **Landscape with Figures (North Balwyn)**, c.1951, gouache on card, 399 x 601 mm (Estate of Fred Williams)

Overleaf, top: fig. 3b **Profile of a Woman Facing Right**, c.1946–51, dyeline print in dark blue ink on paper, 198 x 119 mm (image) (Estate of Fred Williams)

Overleaf, bottom: fig. 3a **Profile of a Woman Facing Left**, c.1946–51, dyeline print in dark blue ink on paper, 198 x 119 mm (image) (Estate of Fred Williams)

The National Gallery School, founded in 1870, was the leading institution of its kind in Melbourne, and occupied premises directly adjoining the National Gallery of Victoria. Students had ready access to the Gallery's collections, including those of the Print Room, and to its exhibitions. Teaching at the School followed the academic tradition, beginning with drawing in charcoal from plaster casts of classical sculptures, whose forms the students were taught to render in tone rather than line.[5] At the time Williams was there, the instruction offered was informal in the extreme, almost laissez-faire, and it was generally agreed that students learned as much from each other as they did from their teachers. Classes at the National Gallery School were open on weeknights from 7 to 9pm, convenient hours for the working man. However, since Williams and his friends wanted to move more quickly than drawing from casts allowed, they looked further afield and decided to attend evening life classes at the Victorian Artists' Society, an association that had run regular life classes since 1917.[6] In addition, whenever possible Williams went to life classes privately organized by individuals.

The focus of Williams's earliest years as a student was on learning to draw and it was as a draughtsman that he first gained public acclaim. Decades later he would reflect in his diary on his belief in the importance of drawing:

> I have always looked on drawing as the final critical analysis of any artist's work. Have often thought that I have never had any idea of "how" artists should be trained – but a pencil & paper tells you a whole lot – & people simply do not change – drawing exposes all. Certainly true of me.[7]

While his weekdays were occupied with earning a living and his evenings with drawing from casts and from the live model, the weekends were given over to sketching outdoors in the company of his art school friends, especially Harry Rosengrave (1899–1986)[8] and Ian Armstrong (b.1923)[9]. Lilydale, some 40km (25 miles) east of Melbourne, became a favoured destination, but Williams and his friends also sketched closer to home on the outskirts of suburbia.

From the beginning Williams used gouache for his plein-air paintings – and he continued to do so to the end of his career, even after 1969 when he took up painting outdoors in oil. These early gouaches, some of which were begun outdoors but then worked up in the studio, were exercises in observation and in composing in colour in front of the motif. While they occasionally displayed Williams's awareness of the formal traditions of European landscape painting, they were, on the whole, naturalistic renderings, painted with a broad brush. At times, when the subject seemed lacking in obvious focus, Williams would compose his picture in ways that prefigure the manner he was to evolve years later in Australia. *Landscape with Figures (North Balwyn)*, c.1951 (fig. 2), with its clear, hard zones of land and sky and the wheeling flock of calligraphic birds at the lower left, is a good example of this hint of future directions.[10]

In 1946, after more than two years of part-time study, Williams finally enrolled as a full-time student at the National Gallery School. He upgraded himself immediately to the School's painting studio, where formal instruction was as scarce as it was in the drawing department. That year he also first met the recently

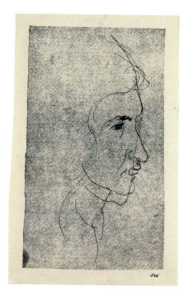

demobbed John Brack, seven years his senior, who was to become a distinguished painter, a lifelong friend and perceptive writer on Williams's art.[11] In the same year and while the School underwent major staffing changes, Williams chose to study under its newly appointed head, William Dargie (1912–2003), a professional portraitist who painted tonally in a realist manner. Dargie employed two new teachers, Murray Griffin (1903–1992) and Alan Sumner (1911–1994), the former being a leading printmaker who was well-known for his skilful linocuts of birds and flowers, the latter a painter who made pioneering screenprints. Printmaking, however, was not included in the School's curriculum, and opportunities to discover more were apparently not sought by the students.

The only evidence of Williams's early interest in the multiplication of images occurs in the group of dyeline prints that he made after his drawings, at some stage between 1946 and 1951. These prints demonstrate that, far from using the technique merely as a curious form of duplication, Williams experimented with it creatively (see figs 3a–b, 4a–b, 5). He explored the possibility of colour variations, he tested the effects of image reversal and he clearly appreciated the grainy, aquatint-like texture that could be obtained using the dyeline process. In a number of the prints he even played with creating margins around the subject, in emulation of a plate-mark. But he did not make editions and did not take the experiments further.[12]

Williams's contemporaries have left vivid first-hand accounts of the all-consuming, even ferocious engagement of the young artist with his art. Brack, who shared a studio with Williams in the late 1940s, would later recall that he was:

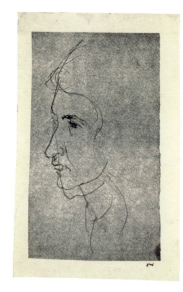

> the most farouche painter I had ever seen. Tubes of paint were not unscrewed, they were simply chopped in half. The procedure was frenetic. Frequently, when the brush seemed too slow, the paint was applied impatiently, even desperately, with a rag. Everything was covered with it, walls, floor, furniture.[13]

Ian Armstrong wrote that Williams

> could not produce a finished drawing in the sense or fashion expected in the school ... the way Fred drew was radical, quickly discarding sheet after sheet of paper in clouds of charcoal dust.[14]

To balance the conservatism and lack of formal instruction at the National Gallery School, Williams decided to attend classes at George Bell's private art school.[15] Bell's school was considered the most progressive of Melbourne's independent art schools, although his ideal was a mild variety of modernism that had emerged from his own studies at London's Grosvenor School of Modern Art and, in particular, the teachings of Iain Macnab.[16] In opposition to the emphasis placed by the Gallery School on modelling in light and dark tones, Bell taught that colour and line should be used to articulate form. Bell could be prescriptive, even authoritarian about his beliefs, but his classes, which included discussions about modern painting, provided a stimulating alternative.

The real avant-garde of the 1940s in Melbourne was led by a generation of artists somewhat older than

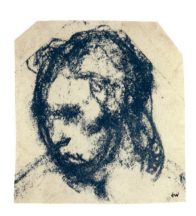

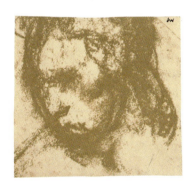

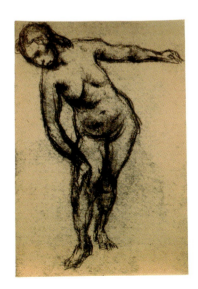

Williams, who had begun to work early in the decade. Chief among them were Albert Tucker (1914–1999), Sidney Nolan (1917–1992) and Arthur Boyd (1920–1999), each of whom forged an original manner from a vigorous synthesis of expressionism and surrealism, indelibly marked by the experience of war.[17] Williams was interested in the work of these artists,[18] but his artistic temperament was very different from theirs. Unlike Nolan and Boyd, he would hardly ever insert figures into his landscapes and he always avoided mythic interpretations of the land. He was more restrained, more deliberate and slower to develop a personal vision.

But Williams's painting and drawing did not go unnoticed. In 1947 he was awarded the drawing prize at the Victorian Artists' Society and in 1949 the National Gallery of Victoria bought one of his drawings; it became the first of Williams's works to enter a public collection (fig. 1). He also entered a painting prize in 1950 and, though he did not win any of the major awards, his paintings were singled out by the influential art patron John Reed, who considered Williams's entries the only works of promise by a newcomer.[19] In early 1951 Williams held his first commercial exhibition, showing jointly with his friends Harry Rosengrave and Ian Armstrong.[20]

In December 1951 Williams left Australia for England, travelling by boat with Ian Armstrong. He was determined to expand his horizons in London, and to continue his education there, both in the formal sense and through looking at the capital's great art collections. While Williams still had much to learn, certain aspects of his practice, informed by certain attitudes of mind that would strengthen with maturity, had already begun to emerge: his unwavering commitment to his art and his immense capacity for hard work, which would become increasingly disciplined and methodical, although always subservient to his artistic instincts.

London and the Music Hall (1952–1956)

Within a few weeks of reaching London in January 1952 Williams had found lodgings at 34 Sumner Place, South Kensington (fig. 6), and a job nearby at Robert Savage's framing shop. He also enrolled at the Chelsea Polytechnic. London, then a city still recovering from war and in the grip of post-war austerity, was not an easy place for the young Australian artists who arrived there in the early 1950s, with expectations that were probably unrealistic. Francis Lymburner (1916–1972), who became Williams's friend and a drawing companion, remembered: 'England, when I went there, was before … the Australian invasion [of the 1960s].… [I]n 1952 we were all an unknown quality and it was terribly difficult to get an exhibition, in fact any recognition at all.'[21] However, Lymburner conceded that, hard though the apprentice years in London might have been, they were a necessary experience for most Australian artists. Away from their familiar ground, they stuck together while making the most of their new contacts. Fred Williams, despite being a newcomer to London, actually managed to be included in three exhibitions in his first year there: several of his small temperas were exhibited in the Kensington Artists' Spring Exhibition at Leighton House in March 1952 and, later that year, a drawing of a male nude was accepted into the Royal Academy's Summer Exhibition.[22] He also negotiated for an exhibition at the Redfern Gallery, and sold two of his works there.[23]

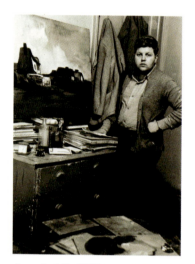

Above: fig. 6 **Fred Williams in his bed-sit**, London, *c.* 1953, photographer unknown

Previous page, top: fig. 4a **Head of a Woman Facing Left**, *c.*1946–51, dyeline print in blue ink, 174 x 167 mm (sheet) (Estate of Fred Williams)

Previous page, centre: fig. 4b **Head of a Woman Facing Left**, *c.*1946–51, dyeline print in ochre ink, 136 x 145 mm (sheet) (Estate of Fred Williams)

Previous page, bottom: fig. 5 **Standing Female Nude Bending to the Left**, *c.*1946–51, dyeline print, 724 x 495 mm (sheet) (Estate of Fred Williams)

In 1953 Williams participated in the first exhibition of the newly formed Australian Artists' Association, held at the Royal Watercolour Society Galleries in Conduit Street.[24] It seems that it was recognition, rather than exhibition exposure, that was hard to obtain.

Williams was not a sentimental man and, in the diaries he kept from 1963, he rarely allowed himself to reminisce about the past. However, on one revealing occasion in 1970 he was prompted to do just that, as he responded with empathy to a plea for advice from the artist Paul Partos, then aged twenty-seven.[25] 'I realise his confused state of mind', he wrote, '& remember how I felt in London almost twenty years ago looking for the identity that I was not sure of & hoping to find some values that would be permanent rather than fashion[able].'[26]

Williams's search for abiding values took different forms. Above all, he continued to draw. On several evenings each week after work he attended the 6pm life classes at the Chelsea Polytechnic and at weekends, from 1954, he would visit friends outside London and go to the countryside on painting and sketching excursions. He also became a valued worker at Savage's, where he handled old master and contemporary paintings of high quality, hence describing the establishment as 'the best art school in London'.[27] Through Savage's he made valuable social contacts with a wide range of artists, including Roger Hilton. The company of his peers, across the generations, was always important to Williams. His letters to John Brack, with their long lists of names of the old masters, whose paintings he was seeing, show that he visited the main picture collections whenever he could.[28] For an ambitious young artist in his circumstances, seeing good paintings was 'a shock to the system',[29] a reminder of the standards to which he aspired.

From around 1953 Williams began to frequent London Zoo to draw the animals, often in the company of Francis Lymburner. These drawings form a distinct and lively group within Williams's oeuvre, showing him testing his observational and technical skills on exotic creatures, and on moving rather than posed subjects.[30] However, the most important motifs in Williams's art during his five-year stay in London were to be found in another, equally artificial if more familiar and comforting environment, the music hall. Williams later explained that he was initially drawn to the music halls for practical reasons: admission was cheap and the theatres were heated, so he could save the money that would otherwise be consumed by the gas meter at home. From his etchings we know that he visited the Angel at Islington, the Metropolitan and the Chelsea Palace.

Williams's companions have left descriptions of the experience of going to the music halls with him. Getting into the Chelsea Palace began with waiting in the obligatory queue before racing upstairs to get the best position. Williams made for the front of the gods, from where he could see the stage unhindered, but where the light was still sufficiently strong to allow him to draw.[31] He sketched the performers, the individuals in the audience and their reactions to what was happening on stage, and views of the boxes with their seated occupants. Occasionally he also took photographs.

Not long after he arrived in London Williams started making linocuts, but the medium did not sustain his

interest for very long.[32] However, in 1954, encouraged by the first efforts of his friend Rod Clarke (b.1927), Williams decided to try his hand at etching and enrolled for the first term at the Central School to learn the basics of the technique. He kept beside him a complete catalogue of Goya's etchings, which he regularly consulted.[33] Once started, his etchings emerged in a flood as he made over one hundred plates during the next two years. His London prints have been grouped into two series that he worked on concurrently. The London Series, of around sixty plates, records the people and events he encountered in daily life, and the Music Hall Series, comprising fifty-three etchings, focuses chiefly on the individual performers of the music hall.

Williams worked with great intensity on these etchings, avoiding preciousness and refinement and learning as he went. Accidental effects were deliberately exploited and remembered for future use. Not surprisingly, the first etchings are a direct extension of the artist's drawings, the earliest of them, *Tumblers*, 1954–5 (Cat. 1, p. 44), being sketched on the spot in the music hall on to a copper plate. The need to depict the darkness of the theatre meant that Williams had to learn the rudiments of aquatint, and he also investigated other, less orthodox means of creating tone.

Though many of Williams's early etchings appear extremely informal, even technically crude, the subjects are in fact carefully composed, both in relation to the space they occupy and in the transformations that are evident as the motif is translated from drawing into print. The very loosely etched sketch of *The Orchestra* (Cat. 3, p. 47) was based not on a single preparatory drawing but on several independent sketches which were combined to form the finished composition. The etching's tonal and linear informality belies the fact that it was created using three successive applications of aquatint over the etched design. *The Angel at Islington* (Cat. 5, p. 57) began as a long vertical plate (Cat. 4, p. 57), but was soon cut to a squarer format in keeping with the proportions of the preparatory drawing (Cat. 81, p. 56). Other plates were similarly adjusted.

Very soon after Williams took up the technique, etching became the driving force in the development of his art, as the number of gouaches and paintings following the prints testifies. Williams used the etching facilities at the Central School and he also tried etching at home, though balancing on the windowsill a tray filled with acid was clearly a risky business.[34] Gaining access to the presses at the School was not always easy, so his first batch of etchings was sent out to a professional printer. Although his identity is not certain, in all likelihood this was the etcher David Strang, who was well known to artists as a professional printer and had been commissioned by the Sickert Trust to print forty-two plates of William Sickert (1860–1942) between 1945 and 1947, including several music hall subjects.[35] It is possible that Williams had seen the posthumous Sickert impressions pulled by Strang, whose printing style was readily identifiable by the even film of ink left on the plates. Williams, however, was not particularly happy with the results he received from the printer because the surface ink that had been left on the plates reduced the tonal contrasts and hence the expressive power of the imagery. As a consequence of such difficulties Williams's London etchings were initially made in tiny editions of between five and ten impressions,[36] few of which have survived. The pulling of the larger editions would have to wait until the artist returned to Melbourne.

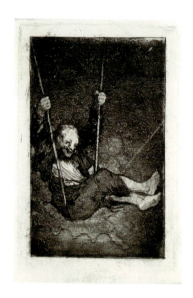 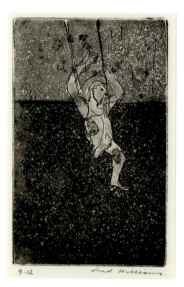

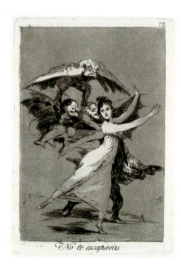

There exists nothing in earlier Australian printmaking that is comparable to Williams's music hall etchings.[37] Their antecedents may be found, instead, within the European printmaking tradition. Closest to Williams in time and place, and in thematic and compositional affinity, was Sickert, for whom the audience of the music hall was a major theme, not least in his etchings.[38] The view of the audience seated in boxes, the orchestra in its pit, and the line of chorus girls in Sickert's etchings all have their counterparts in Williams's music hall subjects.[39] Williams would later remember that one of the printers at the Central School had also printed some of Sickert's plates.[40]

Also of immediate relevance is Goya, whose use of aquatint and other tonal etching techniques Williams studied carefully, both directly from the Goya prints in the Print Room of the British Museum and from books. Goya's subject matter, especially – though not only – the elaborate moral performances of the *Caprichos*, finds an echo in some of Williams's performers. The proportions of the figures in relation to the overall size of the plate and the use of an illuminated subject set against a dark ground are other closely related features (see figs 7–10). Admittedly the respective actors are very different, Williams's being emotionally detached, impersonal; they, like the artist, are outsiders. Because of this they retain a certain melancholy that seems to reflect the artist's own struggle to find his artistic identity during these years.[41]

Pertinent, too, in this context is the example of Degas, some of whose key paintings of musicians and performers Williams could have seen at first-hand in London. The depiction of musicians and audience in *The Orchestra* (Cat. 3, p. 47) is clearly indebted to the format that Degas employed in *Robert le Diable*, in the collection of the Victoria and Albert Museum. Similarly, it is hard to imagine the boldly conceived motif of the woman suspended upside down in *Trapeze* (Cat. 16, p. 53) without the precedent of Degas' *Miss Lola at the Cirque Fernando* in the collection of the National Gallery.[42]

Underlying these precedents and influences is Fred Williams's deep interest in Rembrandt. Williams's experimental approach to etching, his love of the sketchy etched line, and the chiaroscuro of the music hall subjects are all grounded in his knowledge of Rembrandt's etchings (see note 57 below).

Fred Williams's music hall etchings represent the first significant phase of his art. His preference for working in series was now established, while the discipline and planning necessary for the procedures of printmaking were transferred to other aspects of his work. Moreover, the possibilities of change and transformation inherent in the printmaking process became embedded in his way of thinking about images.

By May 1955 Williams was ready to return home. He told John Brack that he had enjoyed London immensely, but wondered whether he might not have learnt the same things about painting better in Melbourne. With respect to drawing and printmaking, however, Williams revealed how crucial his direct engagement with the museum collections had been, adding: 'I have made decided steps in my drawings thanks to the many factors here. B[ritish] Museum etc. have been a great help to me.'[43] Before he left in late 1956 he was at last able to make a quick trip to France, where he visited the museums in Paris, an

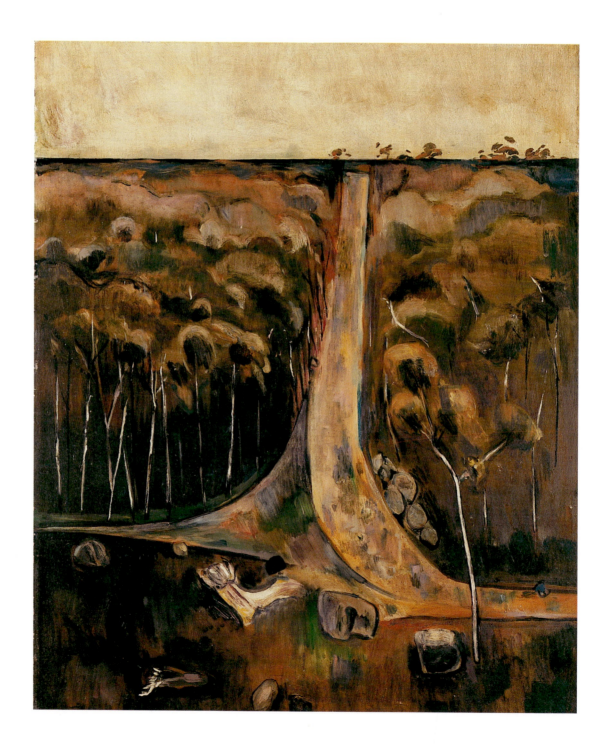

Above: fig. 11 **Landscape with a Steep Road**, 1959 [Cat.24, p. 64]

Opposite: fig. 12 **Landscape with a Steep Road**, 1957, oil on composition board, 1103 x 909 mm (Canberra, National Gallery of Australia, purchased 1979)

experience that confirmed for him the primacy of the French tradition of painting.[44] In preparing for his departure for Australia he had to pawn some of his belongings and jettison some of his work, including oil paintings. But he did not discard his etching plates, which were packed into a small crate for the long voyage home.

Homecoming and the First Landscape Prints (1957–1962)

Williams's moment of vision on seeing the Australian landscape again at Fremantle resolved itself into an obsession. He was not swayed by the doubting reaction of John Brack, with whom he discussed his plans in January 1957. Brack's scepticism was understandable and carried an implicit warning: behind it lay not only the tradition of Australian landscape painting, reaching back into the early nineteenth century,[45] but also in more recent decades the work of both uninspired professionals and mediocre amateurs who had churned out countless pictures of gum trees. By 1957 the subject would certainly appear to have been done to death. But Williams's purpose was clear and he would not be diverted. He set out immediately to come to grips with the landscape, and within months his distinctive view of it began to emerge.

First, however, he set about reintroducing himself to the Melbourne art world by exhibiting the work he had produced in London. In the first half of July 1957 the newly established Australian Galleries showed twenty-seven of his paintings and thirty gouaches. Immediately afterwards he exhibited forty of his London etchings at the Gallery of Contemporary Art. This was one of only four solo print exhibitions that took place in Melbourne during the 1950s.[46] The exhibitions were not commercially successful, although the National Gallery of Victoria purchased three of Williams's etchings.[47] Soon afterwards he travelled to Colo Vale, near Mittagong in New South Wales, to paint and draw outdoors and he made several return visits there until the early 1960s. On these occasions he stayed with his friends John and Joan Stephens, to whom he had been introduced by John Brack.

The Mittagong landscapes were the first landscape series that Williams made after his return to Australia. In them he grappled with the problem of finding an appropriate pictorial form for depicting the individual gum tree as well as the stand of trees in a forest or on open ground. He also experimented with ways of representing space while emphasizing the physical properties of paint. Williams frankly acknowledged that these landscapes emerged from his interest in Post-Impressionism, especially Cézanne. The space in the Mittagong landscapes, and in those that immediately followed, is modelled cubistically while at the same time the picture plane is often tilted forward; there is an emphasis on clarity of outline and a clear division of the component parts of the landscape.

The etchings related to the Mittagong landscapes were begun in 1958 and continued into the early 1960s, *Gum Tree* (Cat. 21, p. 62) being among the earliest. The subject is significant because it represents one of Williams's earliest attempts to find new ways of representing the tree. It portrays, with graphic conciseness,

Above: fig. 13 **The St. George River, Lorne**, 1959–60 [Cat.25, p.65]

Opposite: fig. 14 **The St George River**, 1960, oil on canvas on composition board, 854 x 1182 mm (London, Tate, presented anonymously)

a slender sapling, arcing gracefully under the weight of the leaves that cluster at the end of thin branches. There are no surviving gouaches or paintings that precede the print, though the design must have been based on preparatory drawings; there are, however, a number of works in other media that follow it: a lithograph made in the same year, a gouache, and three paintings from 1966–7.[48] All of these versions of the subject show the tree oriented in the same direction as in the etching and all were therefore, presumably, executed after it. Williams clearly thought that he had found – or, more accurately, created – a motif that expressed something essential about the shape of the tree. He would later refer to such motifs as 'symbols', in this case meaning that they were perfect pictorial representations, rather than images that stood for something else. A similarly shaped tree reappears rising above the canopy in the watercolour *Saplings, Mittagong*, 1962 (Cat. 83, p. 66), a reminder of the personal language of forms that Williams had begun to devise.

In the etchings of the Mittagong series the absence of colour and the accompanying reduction of detail and tone served to simplify the motif, creating a more emphatic sense of abstraction than is apparent in the paintings. This abstraction is clear in the prints that were made after paintings or gouaches, such as *Landscape with a Steep Road* (Cat. 24, fig.11) and *The St George River, Lorne* (Cat. 25, fig.13), but it is even more striking in other etchings from the late 1950s and early 1960s whose subjects are taken from the vicinity of Sherbrooke Forest in the Dandenong Ranges, around 40km east of Melbourne.

Red Trees (Cat. 22, p. 71), dated to 1958 by the artist, shows how quickly Williams arrived at a radically abstracted depiction of a forest of trees. The etching, which comprises a series of vertical lines and stripes placed against a mottled aquatint ground, is in fact a close-up frontal view of a row of straight tree trunks, with dappled light playing through them. Here Williams eliminated the junction of trunks and ground as well as leafy branches as he proceeded on a formal exploration, interpreting the subject in purely pictorial terms.

Between 1960 and 1962 Williams's pictorial explorations had a dual focus: in addition to experimenting with the motif of regular tree trunks he investigated the motif of evanescent, dappled light and the clumps of moving foliage. In watercolours from this group the identifiable subject disappears altogether in blots and stains of colour that are dropped or flicked onto the paper, in a manner reminiscent of Sam Francis, whom Williams admired and whom he had met during his time in London (Cat. 85, p. 68). The related paintings are tonally more subdued and the paint is brushed on, not applied by flinging or dropping; their dominant earthy ochres and browns are closer to the sepia colour of the prints on which they were based. However, they are also more differentiated in hue and thus provide a clearer link to the subtle colours of the landscape than is the case with the watercolours and the prints.

The related aquatints are small, extremely compressed pictorially, and highly experimental, both with regard to technique and in the way in which they are composed into triptychs and four-panelled compositions, the screen-like effect being distinctly Japanese in character. The individual plates of which such compositions

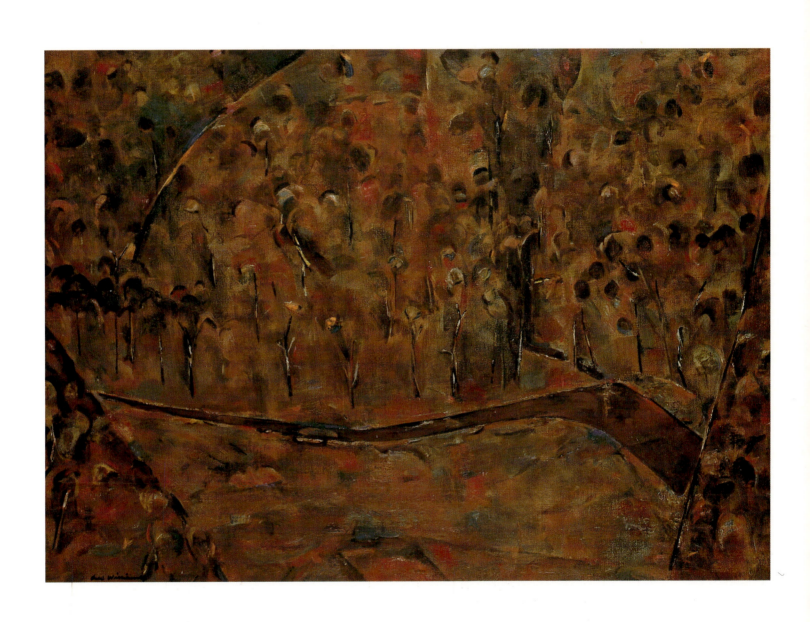

Above: fig. 15 **Echuca Landscape**, 1963, final state [Cat.32, p.75]

Opposite: fig. 16 **Echuca Landscape II**, 1966, oil on canvas, 1220 x 1525 mm (Estate of Fred Williams). The painted version was made after the final state of the etching.

were composed could be arranged in many different sequences (Cats 34, 35, p. 69) and Williams did just that, issuing the plates as separate prints as well as combining them in different ways. It was precisely because of this possibility of change and variation inherent in etching that he considered printmaking a major medium and of equal importance to painting.

Williams usually painted slowly, working on several paintings concurrently, and with most pictures taking many months to complete. This slowness was due in part to the artist's respect for the materials of painting, but, as his diaries repeatedly show, he also subjected his work to a continual process of review, never hesitating to cull paintings that he considered unsuccessful, even after he had spent long periods at the easel. In his etchings this process of review can be clearly documented in the different states through which the prints were taken. Sometimes the changes that he made to the plate were corrections, but more often they were part of his creative exploration of the image.

One of the best examples of works that reflect this approach to etching is *Echuca Landscape* (JM 185) begun in 1961 and completed two years later. The print went through no fewer than sixteen states, the first three of which established the basic structure of engraved vertical lines (Cat. 28, p. 72). In the fourth state an even area of aquatint was added and subsequently burnished by hand in the centre, thereby introducing an area of light into the aquatint tone. The first edition of *Echuca Landscape*, printed in black ink, was pulled from the seventh state in 1961 and numbered only eight impressions (Cat. 29, p. 73). In 1963 Williams returned to the plate and decided to burnish a vertical band down the centre, at the same time reinforcing some of the existing lines. This new composition was ready for editioning by the thirteenth state (Cat. 30, p. 73). Next, the artist added an area of coarse aquatint to the lower right of the central columnar section and printed an edition of this state in sepia ink (Cat. 31, p. 74). The transformations to the image reached full circle in the following, final state (Cat. 32, fig. 15), when the aquatint was entirely removed by hand burnishing, and the print returned to its original form as a series of engraved vertical lines. Three years after completing the final state of *Echuca Landscape*, Williams returned to it once more, using it as the basis of a painting (fig. 16).

Fred Williams's fascination with the possibility of such transformations was rekindled whenever he handled an etching plate. He therefore preferred to print his own plates, and avoided, as long as he could, having them printed by someone else. After his return from London, and while earning his living by working on weekday afternoons as a framer, he printed on the presses of the Melbourne Technical College.

Printmaking in Melbourne had undergone considerable development during the period Williams spent in England. Artists and their agents had begun to organize print exhibitions for local display and for tour to other cities. This sustained attempt at a revival of printmaking was accompanied by deliberate efforts to explain to audiences the nature of original artists' prints.[49] Instruction in techniques and access to printing facilities had become more readily available to artists, the Melbourne Technical College being at the forefront

in this respect. Williams took full advantage of the presses at the 'Tech', and his sketchy, informal manner of etching, as well as the importance he placed on his printmaking, impressed those around him.[50] From 1961 he began to use the printing facilities on a regular basis, usually going there on Fridays.

The six years following his return to Australia were a period of great artistic experimentation for Williams. Professionally, however, it was a lean time. He held annual commercial exhibitions of paintings, but their critical success did not translate into sales. In 1959 he was omitted from *Antipodeans*, an exhibition that included the work of several of his close friends and was accompanied by a manifesto, written by Bernard Smith, defending figurative art against the onslaught of abstraction.[51] The rejection initially upset Williams but he decided against joining the *Antipodeans* when he was later invited to do so. He sent in pictures for a number of painting prizes, including the 1960 Helena Rubinstein Travelling Scholarship, but again without success.

In other important respects his life was changing for the better. In early 1960, in Sherbrooke Forest where he often painted, he met Lyn Watson, whom he married in 1961; it was a lasting marriage of true minds. That year Williams was included in the landmark exhibition, *Recent Australian Painting*, organized by Bryan Robertson at the Whitechapel Gallery, London. And in 1962 he met James Mollison, then an education officer at the National Gallery of Victoria, who recognized the exceptional quality of Williams's art, and very soon began to catalogue the etchings systematically. Not long afterwards Williams acquired his own etching press.[52]

The Essential Landscape (1963–1970)

The representation of space in the landscape and the development of a painterly and graphic vocabulary of marks became the artist's chief concerns during the 1960s. By November 1962 the Williamses and their newborn daughter, Isobel, had moved into a converted stable and coach-house in Chrystobel Crescent, Hawthorn, within walking distance of the framer's where Williams worked most afternoons. The new quarters enabled the artist to accommodate his proofing press, and to establish a studio, larger than any he had had before.[53] The Hawthorn studio was to have an impact on his paintings, whose size he could now expand. The stylistic shifts that occurred in his art at this time were also assisted by the opportunity he had of being able to stand back from his pictures, allowing their details to configure from a certain distance.

A prominent motif that Williams explored in an important series of drawings, paintings and etchings was the You Yangs, an outcrop of granite hills situated 55km (34 miles) south-west of Melbourne. The hills rising from the plains had intrigued Williams ever since he glimpsed them from aboard the ship bringing him home to Melbourne in 1957, but it was not until the winter of 1962 that he began to visit the You Yangs on drawing excursions.[54] The drawings and gouaches that Williams made in the You Yangs initiated a rich series of landscapes produced over the next four years. These were the works in which he formulated a unique visual language of marks to describe his perception of the landscape, whose monotony and absence of focal points and conventional picturesque motifs provided exactly the spur he needed for his compositions.

The series is well documented from 1963, the year in which Williams began keeping a diary in order to record his activity in the studio. He continued this practice to the very end of his life, writing entries every single day, with the result that the diaries are documents of the greatest importance for the study of his art.[55]

The You Yangs series began with a group of naturalistic gouaches, but soon evolved into two contrasting formats which Williams worked on simultaneously. One was the highly abstracted, distant view from the peaks overlooking the sparsely vegetated plain; this group of works dealt with the transforming effects of distance on the details of the landscape. The other was the view looking back towards the hills themselves, seen from a much closer distance, imagery that focused on the rendering of volume in large land forms.

Among the earliest and most beautiful of the gouaches is *You Yangs Landscape* of 1962 (Cat. 84, p. 78), a work that combines both of the viewpoints that Williams had developed for this subject. At the lower left is a close-up view of large boulders rendered in simplified, blocky washes, and beyond them is the far view across the plain, depicted by means of short brush strokes and clusters of dots. In the middle distance is an irregular band of trees, a motif that became the subject of several independent paintings and etchings (Cat. 38, p. 82, Cat. 39, p. 83).

Williams's 1963 diary opens with a record of an extraordinary surge of activity in the first days of January, documented in tiny schematic sketches of the You Yangs etchings and of the related paintings and drawings. At this stage Williams worked in all media simultaneously throughout the week, though on any given day he would focus on a single medium. The major You Yangs etchings (Cats 36–42, pp. 80–85) were begun in January 1963, and over the next few months Williams continued working on these, as well as earlier subjects, at the Melbourne Technical College. Tate Adams (b.1922), who took over the running of the College's print workshop in 1960, has remarked on the intense way in which Williams worked, totally focused on printing and pulling a large number of impressions at each session.[56]

The chief representation of the close-up view is the etching *Knoll in the You Yangs* begun in 1963 (Cat. 40, fig. 17). It is Williams's most important and ambitious aquatint and one whose details he struggled to perfect. The subject is related to a series of gouaches and drawings of a particular hill, whose proportions, Williams said, reminded him of the clusters of buildings and trees in Rembrandt's drawn and etched landscapes.[57] In its dramatic use of aquatint Williams's print is, however, much closer to Goya. James Mollison has recorded that Williams took the etching through as many as thirty-five states, as he fine-tuned the balance of dark and light tones in order to achieve the desired effect.[58] In the end he retained eighteen of the states as a record of the print's development. Having finally obtained what he wanted, Williams printed the etching in an edition of twenty-five impressions. A year later he returned to the plate, cutting it in two in order to make two separate vertical landscapes, one of them reoriented to create a horizon in place of the diagonal incline of the hill (Cat. 42, p. 85). In 1965 Williams used the large plate as the basis for a painting (fig. 18), doing the same with a cut fragment of the left half of the large plate, squaring it for transfer to

Above: fig. 17 **Knoll in the You Yangs**, 1963, final state [Cat.40, p.84]. The etching plate was later cut to create two new compositions [Cats 41 and 42, p.85].

Opposite: fig. 18 **Knoll in the You Yangs**, 1965, oil on canvas, 1501 x 2062 mm (Collection of Lyn Williams). This painting was made after the etching, before the plate was cut in two.

canvas.[59] Williams always considered a composition from every possible angle,[60] playing with scale and spatial definition by altering the size of the support or by inserting a horizon line where it did not originally exist; in his prints he considered the effects of reversal by counter-proofing (Cat. 10, p. 55). Such permutations often seem endless, especially in his etchings, where every change could be recorded if the artist so desired.

The potential for infinite variations on a theme satisfied Williams's strong formalist impulse, something that he continued to refer to in interviews and in his diary entries. In his 1969 diary he wrote that he worked 'on the assumption that "formal" invention is endless',[61] and the following year he explained: '… I only use the subject matter as an excuse to hang the picture on.'[62] Williams's approach to printmaking was organic, as he described it in an interview in 1965:

> I never really know what is going to happen with an etching. I start off with an idea but it often turns out to be quite the opposite to what I started out [to do] so really it takes shape while I'm doing it.[63]

This apparent disavowal of planning should not be taken literally, for here Williams was speaking in the context of an interview and was at pains to emphasize the creative aspects of printmaking. In fact he always planned his work very carefully, with the creative process then taking over. As he was later to remind himself in his diary, for a painter 'to do too much thinking without the brush in hand' was a dangerous thing.[64]

The distant-view format of the You Yangs series is arguably the most important and best known of Williams's landscape inventions (Cats 36–9, pp. 80–83, Cats 43–6, pp. 86, 88). The dots and brush marks of the paintings represent the vegetation scattered over the landscape, clustering at fence lines and tracks, and appearing to become denser where the land rises and falls. The perspective is very like a bird's-eye view, wherein features of the landscape such as the vegetation lose their particularity and appear literally to become dots. The You Yangs drawings, which were mostly executed in black and brown chalk, often heightened with white, are composed with short, spontaneously applied strokes and dots, smudged in places and combining to create a surface that is lively and inflected, rather than mechanical or patterned (Cat. 86, p. 79).

In the etchings the dotted marks were initially created with patches of aquatint, but later were achieved through a system of calligraphic linear strokes and curves. *You Yangs Landscape Number 1* (Cat. 36, p. 80) is one of the canonical works in the series and relates to an important painting that remains in the artist's estate. The early and later, cut states of the print (Cat. 37, p. 81), clearly show the ways in which Williams experimented with the depiction of space by adding horizon lines or homing in on a distant motif by reducing the size of the plate. He did exactly the same thing with *You Yangs Pond*, the early state of which is a distant view (Cat. 38, p. 82), the later state being cropped to a close-up (Cat. 39, p. 83).

In July 1963 Williams won his first major art award, the Helena Rubinstein Travelling Scholarship, and

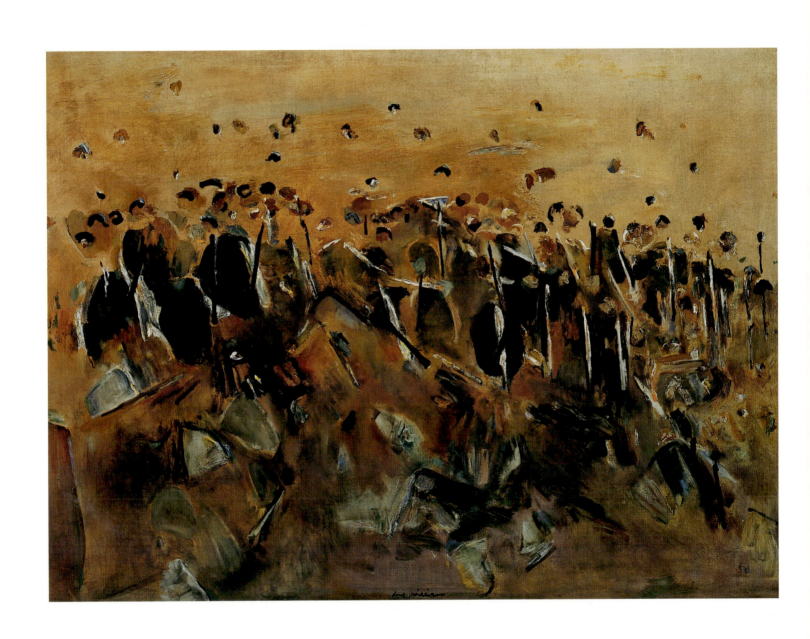

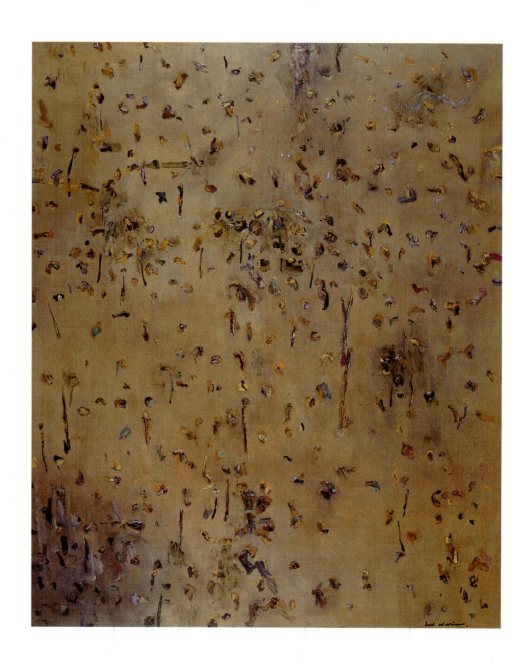

Above: fig. 19 **Forest of Gum Trees**,
1965–6 [Cat.51, p.95]

Opposite: fig. 20 **Forest of Gum Trees III**,
1968–70, oil on canvas, 1835 x 1526 mm
(Estate of Fred Williams)

immediately started planning an art tour of Britain and Europe. A month later he joined the stable of artists who exhibited with the Rudy Komon Gallery in Sydney under an arrangement that gave him a monthly stipend of £80. For the first time in his life, at the age of thirty-six, he thus enjoyed a measure of financial security. In late August the same year he and his wife Lyn bought their first house, in a valley in rural Upwey, in the foothills of the Dandenong Ranges, an hour's drive from Melbourne. It took the artist many months to settle in and establish a new studio and etching room. Before his departure overseas in late May 1964 he started work on several new etchings, completed the final versions of *Knoll in the You Yangs*, and made several lithographs of You Yangs subjects (Cat. 80, p. 87). However, an intensive resumption of printmaking had to wait until his return from Europe on the last day of December that year. In 1965 Williams embarked on a new series of paintings based on the landscape and the garden surrounding the Upwey house and the nearby areas in Upwey and Lysterfield. These pictures built on the compositional formulations and calligraphic vocabulary of the You Yang landscapes.

While visiting Paris and London in 1964, Williams had bought etching materials, including tools and sharpening stones, which he found invaluable back home in Melbourne.[65] His printmaking accelerated as a result of the new studio and the pressure of having to prepare for an exhibition of one hundred prints, to be shown as part of Melbourne's Moomba Festival of 1966.[66] In 1965 alone the artist began work on forty-two new etchings, some of which were completed during the following year. By this time, too, James Mollison's catalogue of the etchings had reached an advanced state and Williams's dealer Rudy Komon decided to publish it.

This development further stimulated Williams's etching, as he printed, for inclusion in the catalogue, new editions of recent prints and reprinted many of the earlier plates, including those he had made in London in the 1950s. He began using Japanese paper[67] and coloured Ingres paper[68] for the first time. Williams enjoyed making the reprints and was happy with them, though he found that some of the plates had corroded and were therefore difficult to print. For the catalogue project he had to review and reassess his entire etched oeuvre, which also meant reviewing and consolidating his whole artistic output over more than a decade. The prints were now given precedence over his other work and several important etched subjects were later translated into major oil paintings. A case in point is *Forest of Gum Trees* (Cat. 51, fig. 19), which served as the model for a painted version of the subject dating from 1968–70 (fig. 20).[69] In some cases Williams also made etchings that summed up a series of works, *Landscape with Green Cloud and Owl* (Cat. 50, p. 89), for example.[70]

As he reviewed his own prints he returned to thinking about Rembrandt and studied his etchings in a catalogue raisonné.[71] This reflection prompted Williams to consider abandoning the use of aquatint in favour of other means of creating tone by intaglio, especially drypoint.[72] Finally, he wrote in his diary on 9 May 1965, he felt he had 'a complete grasp of the medium', adding: 'it has certainly taken a long time.'

Williams's tremendous etching effort continued through 1966 and into 1967, even surviving a broken arm.[73]

During these two years the Williams family was extended with the birth of a second daughter, Louise, in March 1966, and their third child, Kate, in April 1967. The childhood of the three daughters, with all its antics and celebrations, is amply recorded in Williams's diary through words, sketches and photographs, some of which later emerged as etchings (see Cat. 73, p. 59).

Preparations for the publication of James Mollison's landmark catalogue raisonné reached their final stage in 1968, by which time the artist needed a respite from the heavy work of printing. Published in August 1968, the fruit of seven years' labour, Mollison's publication was the first scientific catalogue raisonné of an Australian artist's prints. Two other events of special note occurred in 1968. On 19 February a bushfire raged in the Dandenongs, missing the Williams house so narrowly that some of the paintings, which had been removed from the house for safety, were singed. The aftermath of the fire became the subject of a series of works, including a number of etchings of the regenerating vegetation (Cat. 56, p. 110). And in late June, at neighbouring Ferntree Gully, Williams began sketching outdoors in oils, an important change in practice for hitherto he had used gouache in these circumstances. Increasingly from now on his plein-air painting would be in oils. Williams continued to paint outdoors with gouache occasionally, but only when he went on holiday or on special excursions far afield.

One such period of gouache painting occurred in the first weeks of January 1969, just after the Williamses had moved out of their Upwey house into their next home in Tooronga Road, Hawthorn. The family spent an enforced holiday at the bay-side township of Mount Martha on the Mornington Peninsula, near Melbourne, as they waited for the electricity to be reconnected at their Hawthorn house. The gouaches painted at Mount Martha are extremely disciplined in their geometric format, and restrained both in tone and in their even, flatly painted surfaces. To underscore the minimal nature of these works, Williams for the first time used masking tape to reorganize the proportions of the composition on the sheet and to achieve sharp contours. This practice would soon become for the artist the catalyst for devising the strip-format gouaches in which two or three separate panoramas were placed one on top of the other, separated by narrow strips of unmarked paper which had been protected by masking tape during painting. Williams's diary entry on Friday 24 January 1969 included three thumbnail sketches of gouaches he had worked on that day, one of which recorded the triptych proportions of *Australian Landscape No. 10* (Cat. 87, p. 96). The diary notes also included the comment: 'I suppose the most universal picture is a map. It's worth thinking about.' Two days later Williams announced that he had finally 'made the subject matter subservient to the picture'.[74] The print most closely related to the minimal style of the Australian Landscapes is, however, *Canberra Triptych (Lysterfield)* (Cat. 55, p. 97), made after a painting from the earlier Lysterfield series which had been purchased in 1970 by the National Gallery of Australia in Canberra, hence its title. Williams had actually started this etching on 28 February 1968, while briefly hospitalized, but, having made 'a few tentative scratches' on the copper plates while in his hospital bed, he found he did not have the energy to continue and the etching was put aside for later.

By the end of the 1960s Williams's reputation in Australia was firmly established. He had won several prestigious art awards[75] and his annual sale exhibitions at the Rudy Komon Gallery had become financially successful, some of them being sell-outs. He regularly exhibited his prints, both independently and in group shows within Australia and internationally. The 1960s upsurge of interest in printmaking in Australia, with Melbourne the centre of activity, was a development with which Williams was deeply engaged, both as an artist and as an active participant in professional discussions. He was, for example, one of the founding members of the Print Council of Australia (founded 1966). Williams's standing as an artist was awarded institutional recognition in 1970 when the National Gallery of Victoria gave him his first major museum exhibition, *Heroic Landscape: Arthur Streeton and Fred Williams*, in which his work was paired with one of the 'old masters' of Australian art.[76]

A Vision Cut Short (1971–1982)

By the end of 1970 Williams recognized that his reputation was 'about as good as it's possible [to have]', but he was restless for his art: '… I am feeling [a need for] a change of direction but have absolutely no idea of what form it will take.'[77] In fact, ideas about possible new directions had already begun to germinate during the late 1960s, when he began to think about colour. It was primarily the colours of the landscape that astonished him when he first visited the Australian outback in October 1967. On that occasion he travelled with fellow artist Clifton Pugh (1924–1990) to Tibooburra in north-western New South Wales, recording in his diary a vivid account of his reaction to the landscape which he described as being pure sulphur and lilac one day, and violet, orange and oxide green two days later.[78] By 1972, spurred by his first visit to the forests of sub-tropical Queensland in the previous year, the desire to paint colour had become fierce, 'but based on observation – at this stage anyhow.'[79] Williams decided to alter his palette to incorporate the primary colours, and thus to heighten the overall chromatic range of his painting. This bold decision to change the direction of his art was not fully revealed until May 1975 when an exhibition of his recent paintings was shown at the University of Melbourne.[80] To viewers who had identified Williams's paintings with restrained tonal colour the works in this exhibition came as a real surprise.

The brightening and intensification of colour in the paintings of the early 1970s was matched by a parallel development in the etchings. Here Williams began to rely more consistently on direct engraving techniques. After first scoring the plate deeply with a drypoint needle, Williams would then use his newly acquired electric hand-engraving tool, to produce patches of strong, dark burr that served to intensify the tonal contrast between the white paper and the inked marks. *Silver and Grey Landscape*, 1971 (Cat. 57, p. 101) is a fine early example of this move towards heightened tonal contrasts. The print is a free interpretation of an earlier painting, which itself was created in emulation of the effects of intaglio techniques.[81] Williams also occasionally made drypoint serve a representational function, as can be seen in *Fern Diptych Number 2* (Cat. 56, p. 110), where the dense blackness of drypoint was used to depict the freshly charred wood of the

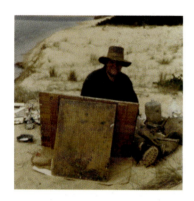

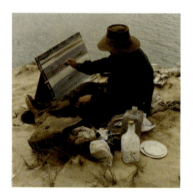

Above and top: figs 21 and 22
Fred Williams painting the gouache Bega No. 1 [Cat.84, p.109 and back cover] at Bournda National Park, New South Wales, 22 January 1975, two photographs by Lyn Williams, pasted into the 1975 Diary (Estate of Fred Williams)

fern trunks. Other engraving tools that he began to use consistently in the 1970s were a variety of roulettes (which he also used through etching grounds), and mezzotint rockers. The purchase of an electric buffing machine in 1974 allowed him to polish his etching plates more efficiently, thus also helping him to achieve the tonal contrasts he aimed for.

As Williams embraced the use of engraving techniques in his etchings, so he determined to stop using aquatint.[82] He did so partly in response to the stylistic shifts that were occurring in his art, and partly in reaction to the prevailing trends in printmaking in Melbourne. The strongest and most influential force among the younger generation of Australian printmakers of the 1970s was George Baldessin (1939–1978), who taught printmaking at the Melbourne Institute of Technology and exhibited regularly. Baldessin's etchings were distinguished technically by their large size and their strong use of extended areas of exquisitely even aquatint.[83] Williams admired the work of his younger colleague and friend, but thought that his prints had become too big, aspiring in effect to be paintings. As he himself moved towards simpler, more graphic means of etching, Williams also reacted against what he considered the over use of refined aquatint tone. 'The big difference in my new plates', he wrote in September 1974, 'is that I don't want to use aquatint anymore – clean plates & black lines.'[84] In fact Williams did not entirely stop using aquatint, but when he incorporated it he did so in a deliberately coarse way. It was texture, not simply tone, that he was after.

In 1972 Williams accepted a new responsibility in his professional life. He had always refused to take up teaching and bureaucratic appointments, afraid that they would erode his time and keep him away from his art. However, he also had a sense of public duty, a keen interest in art museums and their history, and a commitment to the welfare of artists; so in April 1972 he accepted an appointment to the Commonwealth Art Advisory Board (CAAB) (which, in the following year, was reconstituted as the Australian National Gallery Acquisitions Committee). In 1973 he was also appointed to the Visual Arts Board of the Australia Council. He was especially committed to the development of policy and to the acquisitions programme of the Australian National Gallery (later renamed National Gallery of Australia), whose director designate was James Mollison.[85] The last decade of Williams's life was greatly affected by these involvements: at the end of 1973 he calculated that he had attended more than twenty formal meetings of both boards, as well as many informal ones.[86] In spite of these difficulties, and although his participation involved considerable sacrifice, he chose to continue his involvement with the Australian National Gallery, remaining on the Board to the end of his life. His frequent exhaustion from preparing for meetings and from travelling around Australia to attend them, and his frustration at being kept away from his art, are palpable in the diary.

The areas of Williams's art that suffered most as a result of his official commitments were his time in the studio and his printmaking. During this period his priority was given to painting outdoors, an activity that he found totally engrossing and reviving. As he wrote:

I always enjoy getting out & observing things. It's interesting to me that when I finish painting – no

matter how good or bad, my reflexes are so strong that I could paint anything at all – and I mean it. Observation is the catalyst for me![87]

In April 1972, just before his appointment to the CAAB, Williams was invited to paint a mural for the new Adelaide Festival Theatre. He accepted the commission, one of the rare occasions on which he agreed to work under such an arrangement. Due to the position that was allocated for the mural, he decided to make two ensembles of paintings rather than a single work, and the project took him almost a year to complete. The two ensembles – the first comprising eight panels, the second five – were finally dispatched from Melbourne to Adelaide in May 1973. Williams had begun the etched versions in March that year[88] but the printing of the editions was not completed until November 1974[89] (Cats 60–68, pp. 103–7). The date inscribed on most of the edition impressions – 1972 – may, perhaps, be explained by Williams's belief in the overriding importance of 'concept' in painting[90] and, since the concept for the Adelaide Festival Theatre Mural etchings originated in 1972, that was the date assigned to the editions. The long, panoramic format of the etchings mirrors the proportions of the paintings, but the ultimate source for the prints was the strip gouaches that Williams had begun painting in 1971[91] (see figs 21, 22 and Cats 89, 88, pp. 108–9).

Although Williams proofed many of the Adelaide Festival Theatre Mural etchings himself, he simply did not have time to print the editions.[92] The decision to engage a printer was long in coming and difficult to make, but Williams realized he had no alternative if he was to meet his exhibition commitments, let alone make new prints.[93] Accordingly, John Robinson (b.1940), a painter and printmaker, was engaged to print the plates on Williams's press at home in Hawthorn; Robinson began this work on 4 July 1974. The collaboration was a fruitful one for both artists, and Williams was happy with the results. Robinson recalls that after Williams had time to consider the first group of impressions that had been pulled, he asked Robinson not to wipe the plates so cleanly, but to leave a fraction more surface tone on the plate.[94] Editions were kept small, numbering no more than twenty or thirty impressions. Robinson began printing on Thursdays, but this was later extended to include Fridays, in order to have the editions ready for his retrospective of the complete etchings scheduled to open in September 1975 at the McClelland Gallery, Langwarrin.[95] Williams would wet his paper on Tuesday or Wednesday evening in preparation for printing, and would then spend the whole of Wednesday painting outdoors.

A number of the paintings made on his regular excursions outdoors immediately became the subject of new etchings, a process of rethinking and adaptation that Williams thought helped his paintings.[96] The locations that he and fellow artist Fraser Fair (b.1949) visited were often familiar ones, such as Clifton Pugh's property at Cottlesbridge, Ferntree Gully and, closest to home, Kew Billabong. The Cottlesbridge and Kew Billabong subjects are the most successful of the artist's last etchings and their genesis can be traced precisely through his diary notes.

Yarra Billabong, Kew Number 2 (Cat. 75, fig. 23) has its origins in one of three paintings that were begun on

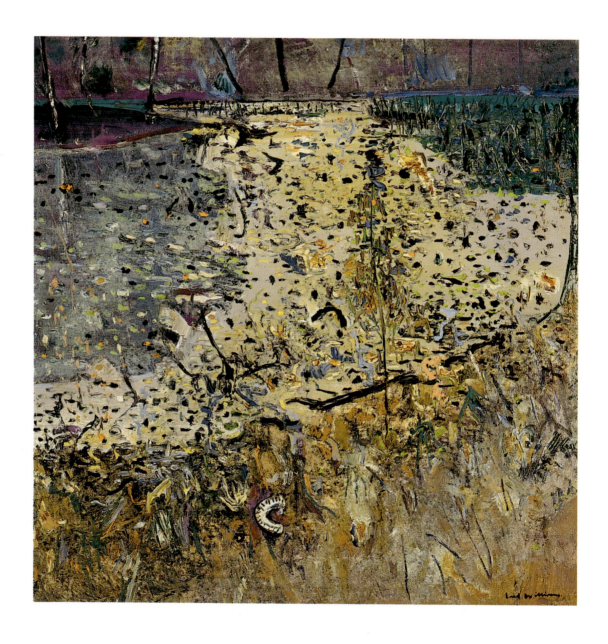

Above: fig. 23 **Yarra Billabong, Kew Number 2**, 1975 [Cat.75, p.117]

Opposite: fig. 24 **Kew Billabong with Old Tyre I**, 1975, oil on canvas, 965 x 965 mm (Estate of Fred Williams)

21 May 1975, *Kew Billabong with Old Tyre I* (fig. 24). These paintings are documented in three Polaroid photographs that Williams took on the day and pasted into his diary, thus providing photographic evidence to support his own written description of the place as being 'splendid – but on the other hand … just a rubbish dump.'[97] Cut off from the River Yarra, the Billabong is a small, secluded oasis of water and native bushland in the middle of suburbia, and is surrounded by gums, strewn with leaves and dappled with light. The curve of its natural shape and its intimate, highly textured appearance are perfectly captured by the small brushstrokes that Williams used in painting these pictures. In the etchings these qualities are conveyed through the speckled appearance of coarse aquatint and by vigorous stippling with the burin and the electric hand-engraving tool.

Williams was greatly stimulated by this his last concerted effort at etching, and he wanted to continue making etchings even – as he thought in passing – at the cost of relinquishing the gouaches.[98] He also fully expected to take his last etchings through further states.[99] However, his official commitments and his exhibition schedule, coupled with the organizational complexities of printing editions and the priority he gave to his painting outdoors, meant that this project never eventuated. Williams's last major prints were a set of twelve lithographs, also printed by John Robinson and published as a portfolio in 1978 by Druckma Press, Melbourne. They provide a compendium of most of the major landscape themes that the artist painted around that time, including Werribee Gorge and some subjects from his late series of paintings of waterfalls. The compositions of the waterfall paintings are informed by Williams's renewed interest in Chinese art, following his visit to China in 1976, when he filled an entire sketchbook with vivid drawings, many of which were worked up as large, finished drawings on his return.[100]

Williams's last series of paintings and gouaches was begun in May 1979 when he first visited the Pilbara region in north-western Australia, at the invitation of his friend Rod Carnegie, Chairman and CEO of the mining company CRA Ltd (now Rio Tinto).[101] Although he thought the country magnificent in its grandeur, colour and light, it took another visit for him to feel that he had come to a sufficient understanding of the region, and could grasp it in terms of paint. '[A]nyone who could <u>not</u> paint this particular country is probably in [the] wrong profession.' he wrote.[102] Yet it was not until 1981 that he found himself able to return to the Pilbara gouaches and to begin painting Pilbara subjects. In the intervening period a major collection-based exhibition of paintings, gouaches and prints was mounted at the National Gallery of Victoria.[103] Also in 1980, Patrick McCaughey's large monograph on Williams was published.

Williams resumed the Pilbara series warily after the long lapse of time away from the subject, but he had his gouaches and photographs to refer to and the paintings soon came with surprising ease. Within three months he had completed over twenty canvases, basing them on the pure, intense colours of the Pilbara country and on the land forms specific to the area.[104] The compositional monumentality of the paintings is both inventive and simple and their pure colours accurately convey the region's searing clarity of light while retaining their independent chromatic values (see fig. 25). These are masterly, exciting pictures. The few new

works that followed the Pilbara paintings were large canvases of remote aerial views of the land and coastline, painted in thin veils of colour, and occasionally stippled with dots and other marks. By contrast with the vivid presence of the Pilbara paintings, the aerial landscapes verge on the ethereal.

For much of 1981 Williams had felt unwell. He had long had a congenital respiratory weakness, which regularly emerged in bouts of asthma (often brought on by acid fumes when he was etching) and, on several occasions, pneumonia, for which he had to be hospitalized. But in November of 1981 he was diagnosed with inoperable lung cancer. He decided not to make further works but to go through everything in his studio, signing or finishing many paintings, drawings and gouaches, and discarding those he thought were not good enough. He died on 22 April 1982 aged fifty-five, at the height of his creative powers.

Fred Williams's premature death came as a shock to the world of Australian art, partly because it was instinctively understood that his passing marked the passing of an era. By virtue of his hard and systematic work Williams had forged for himself a life as a professional artist, placing great value on the traditional studio skills of painting, drawing and printmaking. He constantly and deliberately practised these skills, using his diary as a place to reflect on his progress, as dispassionately as possible. He was keenly interested in what younger artists were doing and therefore deeply engaged in contemporary discussions about art in Australia. At a time when the imminent death of painting kept being announced, Fred Williams expected it would continue, though in ways as yet unknown. He rejected the notion of nationalism in art, though he accepted that art might have a national 'flavour'.[105] He also dismissed what he considered to be the false division between 'internationalism' and 'regionalism' in relation to subject matter, for the only thing that concerned him was 'the end product of the work'.[106]

Fred Williams stands at the end of a tradition as one of the last and arguably the most inventive and greatest of Australian modernist landscape painters. In seeking a higher reality for his art, Williams subjected it to continual challenge from within, so that it never settled into a final formula but underwent constant change. There is therefore no single landscape format that stands out as the archetypal Williams, though his way of composing and his vocabulary of marks are instantly recognizable. Equally, Williams left no school of followers, though his vision – especially as embodied in the You Yangs series – continues to inform the art of a younger generation of Australian landscape painters. The post-Williams landscape in Australia is the post-modernist one.

The landscape genre, which has long been a vessel for the expression of a wide range of ideas and emotions in art, remains an important subject for Australian painters, but its character has changed since Williams's death. The rise of Aboriginal art since the 1970s, especially the Aboriginal view of the land, which lies outside the Western tradition of landscape painting to which Williams and his generation belongs, cannot now be ignored as a significant factor in the Australian context.

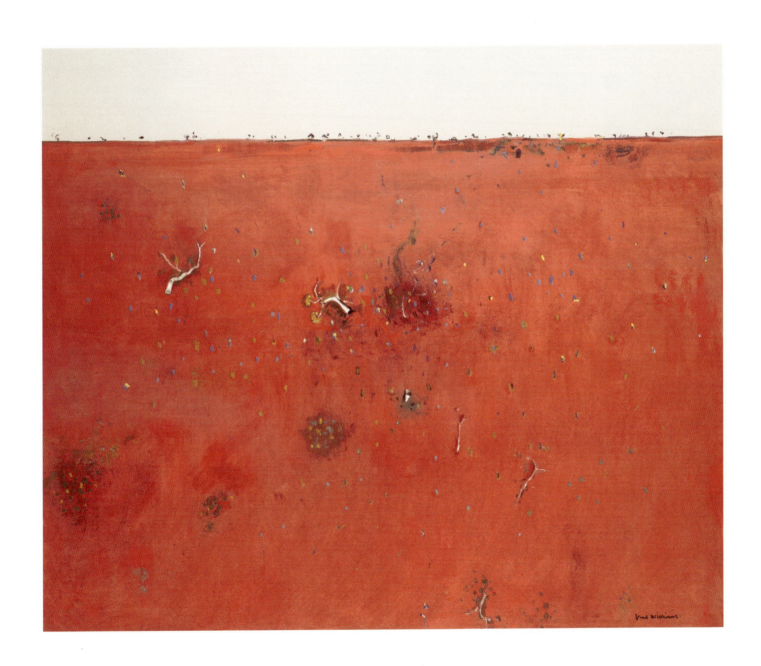

Notes

Fig. 26 **Fred Williams's etching room at Tooronga Road, Hawthorn**, from a group of photographs by Fiona McDougall taken two weeks after the artist's death on 22 April 1982. The press in the foreground is Japanese and was manufactured by Shin Nihon Zokei Co., Ltd.

1 'The first thing that I noticed when I returned…to Australia was the peculiarity of the country', Fred Williams, interview with Hazel de Berg for *National Library of Australia Interview Series*, 8 December 1965. National Library of Australia, oral tape DeB 155 [cited below as FW to Hazel de Berg, 1965].

2 Fred Williams interview with James Gleeson for *Australian National Gallery Interview Series*, 3 October 1978 [cited below as FW to James Gleeson, 1978].

3 The exchange between Williams and Brack was remembered by their mutual friend, Hal Hattam (1913–1994), who related it to James Mollison; quoted in James Mollison, *A Singular Vision: The Art of Fred Williams*, Canberra 1989, p.35 [cited below as Mollison 1989].

4 FW to James Gleeson, 1978: 'There has got to be some explanation [of] why I have always been interested in painting figures and nudes and portraits. When I went to art school that is all I could ever do…. But there has got to be some reason why I did stick to the landscapes as long as I did and this was simply because I just wanted something where I could move with great freedom, and I felt I was at one with it.'

5 A detailed account of the teaching practice of the National Gallery School during the 1940s appears in Mollison 1989, pp.4–9. This information is amplified in Ted Gott, *Fred Williams: Drawing the Nude*, Museum of Modern Art at Heide, Melbourne 2001, pp.5–8.

6 On life classes at the Victorian Artists' Society, see Ted Gott, ibid., pp.8–11.

7 *Diary of Fred Williams*, 11 December 1976 [cited below as *Diary*, with date].

8 Harry Rosengrave was a painter and printmaker. A retrospective exhibition of his prints was held at Niagara Lane Gallery, Melbourne, 1980.

9 Ian Armstrong is a painter, printmaker and teacher. In 1951 he was the joint winner of the Commonwealth Jubilee Travelling Scholarship which enabled him to travel to London, a trip on which he was accompanied by Fred Williams. See Peter Perry, *Ian Armstrong Retrospective 1941–1998*, Castlemaine Art Gallery and Historical Society, Castlemaine 1999.

10 Patrick McCaughey recognized in this gouache an anticipation of later developments. See Patrick McCaughey, *Fred Williams 1927–1982*, Sydney 1996, pp.43–4. The gouache is reproduced on p.44, pl.13 as *Balwyn Landscape, c.*1946.

11 For the catalogue raisonné of John Brack's paintings, drawings and prints, see Sasha Grishin, *The Art of John Brack*, 2 vols, Melbourne and Oxford 1990. See also the exhibition catalogues by Robert Lindsay et al., *John Brack: A Retrospective Exhibition*, National Gallery of Victoria, Melbourne 1987 and Ted Gott, *A Question of Balance: John Brack 1974–1994*, Museum of Modern Art at Heide, Melbourne 2000.

12 *The Focal Encyclopedia of Photography*, London and New York 1969, p.487, describes the dyeline process as one that relies on 'the action of light on diazo compounds…. The process yields a positive image from a positive and the prints are developed by treatment with ammonia vapour or certain organic solutions.' The collection of the National Gallery of Australia, Canberra, has several of Williams's dyeline prints, but most remain in the Estate of Fred Williams.

13 See John Brack's introduction to James Mollison, *Fred Williams Etchings*, Woollahra (Sydney) 1968, p.5.

14 Quoted in Mollison 1989, p.7.

15 For the main literature on George Bell and his school, see Mary Eagle and Jan Minchin, *The George Bell School: Students, Friends, Influences*, Melbourne and Sydney 1981, and Felicity St John Moore, *Classical Modernism: The George Bell School*, National Gallery of Victoria, Melbourne 1992. See also June Helmer, *George Bell – The Art of Influence*, Richmond (Victoria) 1985. It is worth noting that Fred Williams contributed the entry on George Bell to the *Australian Dictionary of Biography*, vol. 7: 1891–1939, Melbourne 1979, pp.253–4.

16 Williams owned a copy of the 1946 revised edition of Macnab's book, *Figure Drawing* (first published 1936). This copy remains in the Estate of Fred Williams.

17 The key text on the activity of this group of artists in the 1940s remains Richard Haese, *Rebels and Precursors*, Ringwood (Victoria) 1981. See also *Angry Penguins and Realist Painting in Melbourne in the 1940s*, exh. cat., Hayward Gallery, London, 14 May – 14 August 1988.

18 Patrick McCaughey, op. cit., p.31, relates that George Bell spoke critically of Sidney Nolan's Ned Kelly paintings when they were first exhibited in Melbourne in 1947, while Williams admitted to liking them. In May 1963 John Reed asked Williams to restore the Kelly paintings, as by that time they were in a damaged state. See *Diary*, May and June 1963.

19 John Reed (1901–1981) and his wife Sunday were the most influential patrons of the Melbourne avant-garde in the later 1930s and 1940s. Reed was joint editor and publisher of the journal *Angry Penguins*, president of the Contemporary Art Society and founder of the Gallery of Contemporary Art. The Reeds' property, Heide, at Bulleen (Melbourne) is now the Museum of Modern Art at Heide, a public art gallery. Reed expressed this positive early opinion about Williams in a letter to Albert Tucker dated 25 June 1950, after he had seen the 1950 Dunlop Prize Exhibition (won by Nolan): 'About fifty of the paintings are being exhibited and I thought they represented quite a fair standard of work even if they lacked any outstanding quality. A new man to me, Williams, is a possible exception. Do you know of him?' See Barrett Reid and Nancy Underhill (eds), *Letters of John Reed*, Ringwood and Harmondsworth 2001, p.469.

20 *Ian Armstrong, Fred Williams, Harry Rosengrave, Paintings and Watercolours*, exh. cat., Stanley Coe Gallery, Melbourne, 27 February – 8 March 1951.

21 'Francis Lymburner interviewed by Hazel de Berg, 20 November 1965' in Geoffrey Dutton (ed.), *Artists' Portraits*, National Library of Australia, Canberra 1992, p.145.

22 See Ted Gott, *Fred Williams: Drawing the Nude*, op.cit., pp.18–19 and p.30 n.13.

23 Williams gave an account of his dealing with the Redfern Gallery in a letter to John

Fig. 27 **Fred Williams's etching tools**, in the etching room at Tooronga Road, Hawthorn, photograph by Fiona McDougall. The artist's electric hand engraving tool lies above the burins at the right of the bench.

24 *Australian Artists' Association 1st Annual Exhibition*, exh. cat., R.W.S. Galleries, 26 Conduit Street, 15–31 January 1953. Fred Williams contributed four paintings: *Morris Dancers* (cat.75), *Sketch* (cat.76), *Tragic Landscape* (cat.77) and *Nude* (cat.78).

25 Paul Partos (1943–2002) was one of the leading Australian artists of non-figurative colour field painting. In late 1968 he was included in the influential exhibition, *The Field*, held at the National Gallery of Victoria.

26 *Diary*, 15 November 1970.

27 This opinion is cited in Mollison 1989, p.17.

28 Within days of his arrival in London Williams reported in a letter of 16 January 1952 to John Brack that he had already made six visits to the National Gallery, the Tate Gallery and the Victoria and Albert Museum. He singled out Raphael ('supreme') and mentioned Uccello, Piero della Francesca, Antonello da Messina, Giovanni Bellini and Titian. Of the nineteenth- and twentieth-century European painters he especially liked Renoir. By 3 March 1952, in another letter to Brack, he reported visiting the Wallace Collection and the Print Room of the British Museum, where he saw Goya prints. The French painters he singled out on this occasion were Claude, Clouet, Poussin, Delacroix, Cézanne and Picasso. Extracts from these letters are cited in Mollison 1989, p.32.

29 Williams used this phrase in a conversation recorded in an article by Ian Turner, 'Artists' Camp Erith Island: March 1974', *Overland*, no.60, Autumn 1975, p.44. A comparable description is contained in Williams's letter to John Brack dated 16 January 1952, quoted in Mollison, 1989, p.32.

30 The main account of Williams's animal drawings appears in Ted Gott, *Fred Williams: Drawing the Exotic*, exh. cat., Museum of Modern Art at Heide, Melbourne 1999, pp.5–11.

Brack, dated 5 September 1952, quoted in Mollison 1989, p.19. It has not been possible to confirm these details with the Redfern Gallery.

31 John and Emmie Taylor's recollection of Williams at the Chelsea Palace Music Hall appears in Mollison 1989, p.20. See also: Kirsty Grant, 'Images of the Music Hall – Fred Williams in London, 1952–56' in *Brought to Light: Australian Art 1850–1955 from the Queensland Art Gallery Collection*, South Brisbane 1998, pp.240–43, and Barry Humphries's introduction in *Fred Williams: Music Hall Etchings 1954–1956*, Townsville 1998. This book contains posthumous reprints of five of the Music Hall plates: *Little Man Juggling* (JM 5), *Dancing Figures* (JM 6), *The Song* (JM 32), *Trampoline* (JM 39) and *Dancer* (JM 49).

32 These linocuts survive mostly in one or two impressions. A small group of them is in the collection of the National Gallery of Australia, Canberra, and can be viewed online at www.australianprints.gov.au.

33 The edition was *The Complete Etchings of Goya*, with a foreword by Aldous Huxley, New York 1943. Williams's copy remains in the Estate.

34 Erwin Fabian recalls Fred Williams telling him this: Erwin Fabian to Irena Zdanowicz, conversation 22 October 2002.

35 David Strang (born 1887– died in the 1960s or early 1970s), son of the etcher William Strang (1839–1921) and brother of Ian Strang (1886–1952), also an etcher, gave a collection of over 600 prints, including etchings by C.R.W. Nevinson, Orovida Pissarro and Sir William Rothenstein, to the Print Room of the British Museum in 1960. The posthumous Sickert restrikes included *The Orchestra of the London Shoreditch, c.*1920 (Bromberg 190), *The London Shoreditch, c.*1920 (B 192) and *In Memoriam, Harry Anderson, Eheu!*, 1922 (B 207), which share a compositional affinity to Williams' own Music Hall plates (see Ruth Bromberg, *Walter Sickert: Prints. A Catalogue Raisonné*, New Haven and London 2000, esp. p.43 and p.304 n.83). I am grateful to Stephen Coppel for the information on Strang.

36 Mollison 1989, p.25.

37 During the 1960s the Melbourne sculptor and printmaker, George Baldessin (1939–1978) made etchings of performers, which were influenced by Williams's music hall prints, but they were conceived in a

surreal and expressionistic manner. See note 83 below.

38 See Ruth Bromberg, op. cit., and n.35 above.

39 For example, compare the following: Sickert's *The Old Bedford (The Small Plate)*, 1910 (Bromberg 135) with Williams's *The Angel at Islington*, 1955–6 (JM 12); Sickert's *The Orchestra of the London Shoreditch*, c.1920 (B 190) with Williams's *The Orchestra*, 1955–6 (JM 9) and Sickert's *Cheerio*, 1928–9 (B 222) with Williams's *'The Boy Friend'*, 1955–6 (JM 52).

40 For an account of the correspondences between the art of Sickert and Williams, see Patrick McCaughey, op. cit., pp.68–79. In relation to the etchings McCaughey writes that the printer at the Central School of Arts and Crafts had offered to print Williams's plates to give them a 'Sickert-like quality'; Williams later discovered that the man had been Sickert's printer (p.68). The only reference to this matter in Fred Williams's diaries appears with tantalizing brevity on 10 December 1971. The day's entry records a discussion with Bill Lieberman: 'Lieberman traces the influences on my etchings to early Graham Sutherland & Samuel Palmer & Sickert (Sickert's printer at Central School)…'.

41 The quality of melancholic isolation in the music hall etchings is remarked on by all writers on Williams's art, beginning with John Brack in his introduction to James Mollison, *Fred Williams Etchings*, Woollahra 1968, p.6.

42 For these two paintings by Degas, see: P.A. Lemoisne, *Degas et son oeuvre*, 4 vols, Paris 1946, no.391 (*Ballet de Robert le Diable*, 1876) and no. 522 (*Miss Lola au Cirque Fernando*, 1879).

43 Fred Williams's letter to John Brack, dated 12 May 1955, is quoted in Mollison 1989, p.33.

44 'My admiration has always been for the French painters, the French way of living, the French attitude, rationalism. All the painters that I can think of that I admire somehow always turn out to be Frenchmen….' FW to Hazel de Berg, 1965.

45 Among the key references on the subject of Australian landscape painting

Fig.28 **Inks, acids, and other etching materials** at the back of the etching room at Tooronga Road, Hawthorn, photograph by Fiona McDougall

are: Tim Bonyhady, *Images in Opposition: Australian Landscape Painting 1801–1890*, Melbourne and Oxford 1985; Leigh Astbury, *City Bushmen – Heidelberg School and Rural Mythology*, Melbourne and Oxford 1985; Ian Burn, *National Life & Landscapes: Australian Painting 1900–1940*, Sydney and London [1990]; Elizabeth Johns et al., *New Worlds from Old: 19th Century Australian and American Landscapes*, National Gallery of Australia, exh. cat., Canberra 1998. See also Margaret Plant, 'Render Unto the Gum Tree', *The Real Thing*, Museum of Modern Art at Heide, exh. cat., Melbourne 1997.

46 This information appears in Cathy Leahy's unpublished MA research essay, 'Printmaking in Melbourne in the 1950s: An Institutional Study', Monash University, Clayton, Melbourne 1997, p.36. The other three solo print exhibitions were by Murray Griffin in 1951 (Sedon Galleries) and Lesbia Thorpe in 1955 (Victorian Artists Society) and 1958 (Tasmanian Tourist Bureau). I am grateful to Cathy Leahy for allowing me to read her essay.

47 The etchings bought were: *Vaudeville* (JM 1), *Finale* (JM 16; Cat. 6) and *The Haircut* (JM 98). The artist augmented this group with a gift of *The Engagement Ring, Number 2* (JM 88).

48 The lithograph was made in an edition of only three impressions. The National Gallery of Victoria's impression (ed. 3/3) is illustrated in Robert Lindsay and Irena Zdanowicz, *Fred Williams: Works in the National Gallery of Victoria*, Melbourne 1980, p.103, no. 268. The three oils were painted in 1966 and 1967 and remain in the Estate. The gouache is known from a photograph.

49 The main account of the development of printmaking in Melbourne in the 1950s is Cathy Leahy, op. cit., especially chap.3, pp.29–46: 'The Revival: Exhibitions, Market and Institutional Support'. See also Lilian Wood (comp.), 'Melbourne Printmaking in the 1950s – Personal Recollections Collated by Lilian Wood', *Imprint*, no.1, 1980, n.p. (2 pp.) and Sasha Grishin, *Contemporary Australian Printmaking, An Interpretative History*, Roseville East 1994, esp. chap.1, pp.21–35: 'The New Age of Printmaking in Australia: Laying the Foundation'.

50 Janine Burke and Suzanne Davies,

'Tate Adams and Melbourne Printmaking', *Imprint*, no.2, 1979, n.p. (3 pp.).

51 The 'Antipodean Manifesto' is reprinted in Bernard Smith, *The Death of the Artist as Hero*, Melbourne and Oxford 1988, pp.194–7. For a survey of Australian art in the 1950s and 1960s, see Christopher Heathcote, *A Quiet Revolution: The Rise of Australian Art 1946–1968*, Melbourne 1995.

52 The press, which he used for proofing, was bought from Allan Jordan on 30 November 1962 for £150. Allan Jordan (1898–1982), a painter and printmaker who taught at Swinburne Technical College, held evening etching classes (begun 1952) which were attended by artists such as John Brack. See Cathy Leahy, op. cit., pp.25–6.

53 James Mollison describes the studio as a former chaff loft, which was well-lit and roughly 5 x 13m in size. See Mollison 1989, p.79.

54 Williams never learned to drive a car and therefore always had to be driven to drawing and painting locations. His first companion on the drive to the You Yangs was James Mollison.

55 Initially, the diaries were small – around 200 x 130 mm – and covered one week per opening, but as the years progressed they became larger – up to foolscap in size – to accommodate his photographic documentation from the studio and from outdoor painting excursions.

56 '[He was] really dedicated. He just stood at that press all day and worked. [He was] totally focused…. He would print a whole edition of twenty four, twenty five, or thirty – something like that.' See *Fred Williams Music Hall Etchings 1954–1956*, op. cit., quoted in the preface by Diana Davies. For Tate Adams, see Janine Burke and Suzanne Davies, op. cit. In 1966 Tate Adams opened the first commercial gallery dedicated to prints in Melbourne, the Crossley Gallery; see Jenny Zimmer (ed), *The Crossley Gallery 1966–1980*, Melbourne 2003.

57 This is recorded in Mollison 1989, p.77. Williams continued to study Rembrandt's landscape drawings. In 1977 he made his first copies of old master drawings from the illustrations in the 1973 edition of Otto

Benesch's six-volume catalogue raisonné, *The Drawings of Rembrandt*, which he had received as a gift from James Mollison. Most of the subjects he copied were landscapes. For an account of Williams's drawings after Rembrandt, see Irena Zdanowicz, 'Selected Affinities: Fred Williams's Drawings after Rembrandt', *Art Bulletin of Victoria*, no.29, 1989, pp. 24–37.

58 Mollison 1989, p.82.

59 This impression is on deposit at the National Gallery of Victoria as a promised gift from Lyn Williams.

60 One feature of Williams's working method was his frequent practice of turning the canvas upside down as he painted. This served to distance him from the subject and thereby allowed him to focus on the formal qualities of the painting. 'I'm strictly an upside down painter,' he joked in conversation with James Gleeson. See FW to James Gleeson, 1978. As an aid to achieving compositional balance Williams also used diagonally crossed wires on both his paintings and his gouaches.

61 *Diary*, 21 August 1969.

62 *Diary*, 5 July 1970.

63 FW to Hazel de Berg, 1965.

64 *Diary*, 25 January 1970.

65 *Diary*, 9 May 1965: 'The sharpening stones I bought in Paris are proving invaluable, [as] are also some of the other tools.'

66 *Etchings by Fred Williams*, Lower Melbourne Town Hall, 4–14 March 1966.

67 *Diary*, 13 December 1966.

68 *Diary*, 25 November 1966.

69 Other examples are *Oval Landscape* (JM 242; Cat. 53), and *Chopped Trees, Lysterfield* (JM 245; Cat. 54).

70 *Diary*, 5 May 1965.

71 *Diary*, 17 April 1965. Fred Williams owned Ludwig Münz's catalogue raisonné, *A Critical Catalogue of Rembrandt's Etchings*, 2 vols, London 1952. His copy remains in the Estate.

72 *Diary*, 17 April and 5 & 14 July 1965.

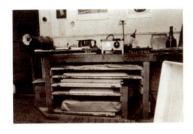

Fig.29 **The electric buffing machine and an electric hot-plate** on the bench in the etching room at Tooronga Road, Hawthorn, photograph by Fiona McDougall. On the pin-board above hangs a small portrait sketch in oils by Tom Roberts, and below to the right a pinned postcard of Rembrandt's etched *Self Portrait (Wide-Eyed)*, 1630, and a reproduction of one of Hercules Seghers's landscape etchings.

73 *Diary*, 17 February 1966.

74 *Diary*, 26 January 1969.

75 The major awards were: Helena Rubinstein Travelling Art Scholarship (1963), John McCaughey Memorial Prize (1966), Georges Invitation Art Award (1966), Wynne Prize (1966), Print Council of Australia Print Prize (1967).

76 *Heroic Landscape, Arthur Streeton and Fred Williams*, National Gallery of Victoria, Melbourne, 20 October–22 November 1970.

77 *Diary*, 26 November 1970.

78 *Diary*, 19 & 21 October 1967.

79 *Diary*, 4 April 1972.

80 *Fred Williams – Recent Paintings: A Current Working Exhibition*, University of Melbourne, 13–30 May 1975.

81 The painting, *Silver and Grey V*, 1969, is in the Williams Estate. Another version of the subject, with the same title, and dated 1969–70, is in the collection of the National Gallery of Australia, Canberra. Speaking about the latter painting, Williams described it as 'a combination of my engraving … etching and aquatints. The process of actually digging a hole in the plate.' FW to James Gleeson, 1978.

82 *Diary*, 20 March 1973: 'I will not again use aquatint – but will do it with a roulette etc….'

83 For Baldessin, see Robert Lindsay and Memory Holloway, *George Baldessin: Sculpture and Etchings – a Memorial Exhibition*, National Gallery of Victoria, Melbourne 1983; Juliana Kolenberg (ed.), *George Baldessin Estate: Prints 1963–1978*, Australian Galleries, Melbourne 1997; and Anne Ryan, *George Baldessin: Occasional Images from a City Chamber 1975*, exh. brochure, Art Gallery of New South Wales, Sydney 1999.

84 *Diary*, 14 September 1974.

85 James Mollison was appointed Director Designate of the Australian National Gallery in 1971 and was Director from 1977 until 1989, when he took up the position of Director of the National Gallery of Victoria (until 1995).

86 *Diary*, 29 & 30 December 1973. This double-page spread includes Williams's summary of important events of the year.

87 *Diary*, 6 March 1974.

88 *Diary*, 19 March 1973: '[C]ut up the zinc plates – thirteen Mural panels & get a coat of wax on them – this takes me all day … I hope to get the etchings started tomorrow….'

89 *Diary*, 28 November 1974: 'John Robinson here … & prints ed of the last Adelaide plate – I'm pleased to have this finished.'

90 *Diary*, 28 May 1973: 'Concept in a painting is everything.'

91 *Diary*, 5 March 1971: 'I do my first gouache today with the masking-tape lines coloured and I'm sure this will eventually be important to the gouaches….'

92 *Diary*, 21 June 1974: '… I must ask about having someone print some etch plates – left to my own it may take me years to get going again.'

93 *Diary*, 22 June 1974: 'George [Baldessin] says that John Robinson would be interested in doing my work (etchings)[.] I jump at the opportunity….'

94 John Robinson, conversation with Irena Zdanowicz, 13 March 2003.

95 *The Etchings of Fred Williams*, McClelland Gallery, Langwarrin (Victoria), 13–23 September 1975.

96 *Diary*, 3 May 1975: 'I will do an etching of the pond at Kew (one that I did last Wed [30 April]. This will help with my Wed Painting – or a change in emphasis…?'

97 *Diary*, 21 May 1975.

98 *Diary*, 19 July 1975: '… I will continue etching as a serious part of my work – probably it will replace doing the gouaches?'

99 Fred Williams made this clear in conversation with Irena Zdanowicz during preparations for the publication of the collection catalogue and exhibition at the National Gallery of Victoria in 1980. See Robert Lindsay and Irena Zdanowicz, *Fred Williams: Works in the National Gallery of Victoria*, Melbourne 1980, p.66.

100 For Williams's China drawings, see Ted Gott, *Fred Williams: Drawing the Exotic*, op. cit., pp.18–29.

101 Williams's core selection of thirteen paintings and eighteen gouaches from the larger group were later purchased by CRA. In 2001 the Rio Tinto company presented the entire group to the National Gallery of Victoria. See Patrick McCaughey, *Fred Williams – The Pilbara Series 1979–1981*, exh. cat., Melbourne 1983; and Jennifer Phipps and Kirsty Grant, *Fred Williams: The Pilbara Series*, National Gallery of Victoria, Melbourne 2002 (with bibliography).

102 *Diary*, 7 June 1979.

103 See Robert Lindsay and Irena Zdanowicz, *Fred Williams: Works in the National Gallery of Victoria*, Melbourne 1980.

104 *Diary*, 20 May 1981: 'The Pilbara is a conscious effort to do pictures based purely on colour & using the peculiar forms of the area.'

105 *Diary*, 22 October 1970: '[Noel] Shaw [who seems to have been doing research towards a thesis on printmaking] comes & I say a few words about Nationalism. I said there was no such thing as an "Aust[ralian]" print only a "Nat[ional]" flavour.'

106 *Diary*, 15 August 1976: 'Colin [Lanceley (b.1938)] remarks that he is a committed "Internationalist" & I am the committed "Regionalist" – I would like to think in the end there is only the end product of the work. I honestly believe you can not approach the problem like this. I even suspect you don't really have the choice…'

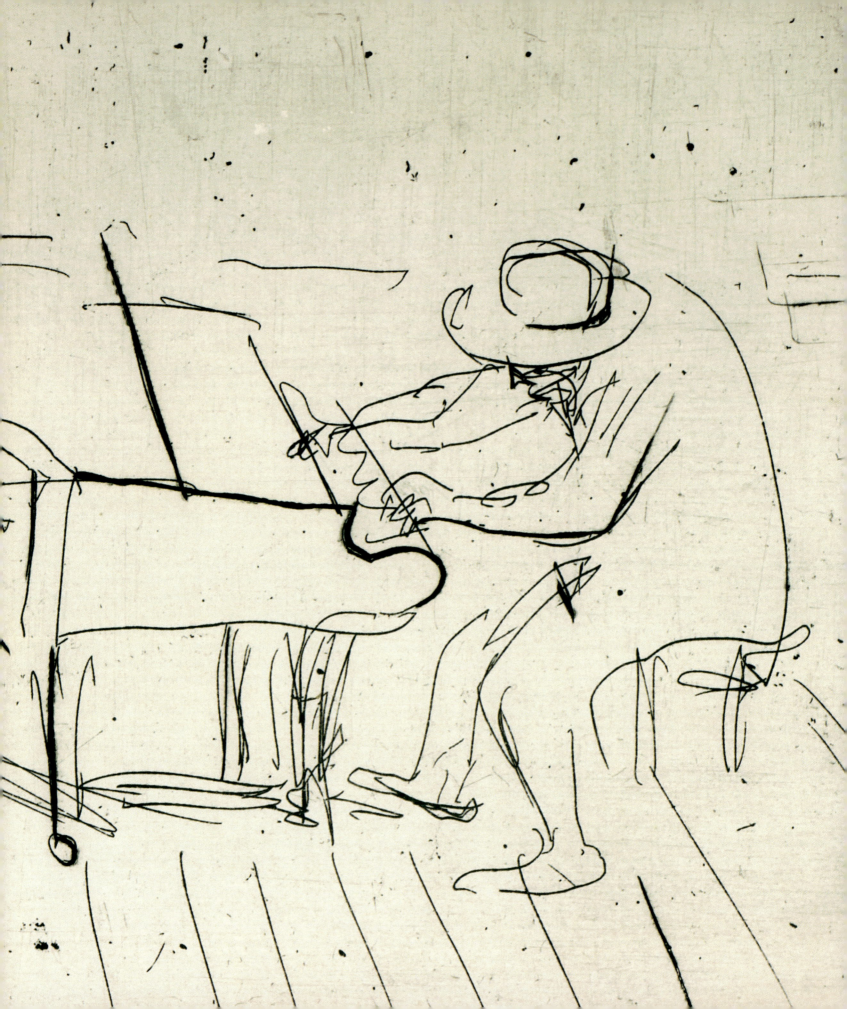

London and the Music Hall

'You'd wait in a long queue and pay your two bob and then you'd run like hell up these stairs to get a good position. [Fred] used to go for the front of the gods, so that he'd get a good position for seeing the stage… He just went there… with his sketchpad and pen… It's surprising [but] there is sufficient light to see… They were just notes, really… just to prompt his memory.'

John Taylor to James Mollison, interview 15 June 1986 (Mollison 1989, p.20)

Tumblers, 1954–5, 2nd state of 2
Etching, 106 x 100 mm [Cat.1]

Trampoline, 1955–6, 1st state of 5
Etching, aquatint and drypoint, 147 x 195 mm [Cat.11]

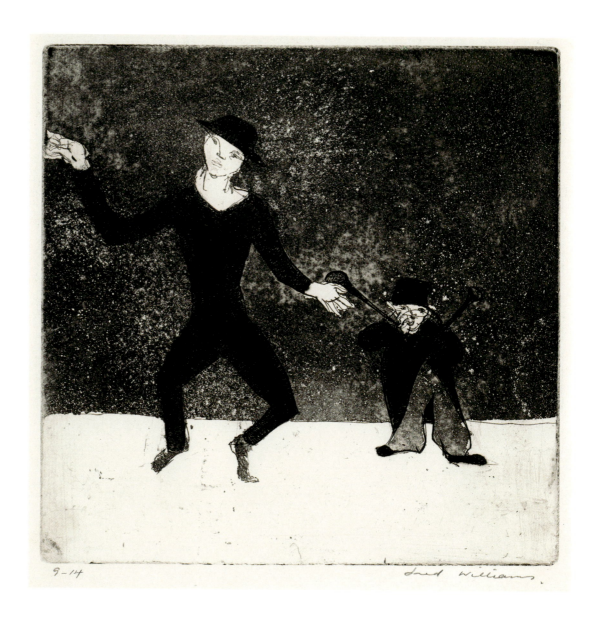

Dancing Figures, 1954–5, 3rd state of 4
Etching, aquatint, engraving and drypoint, 195 x 200 mm [Cat.2]

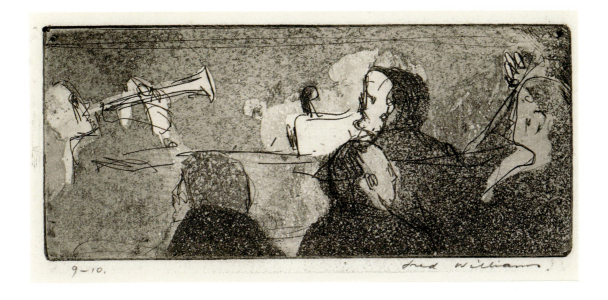

The Orchestra, 1955–6, 5th state of 5
Etching, aquatint and drypoint, 71 x 165 mm [Cat.3]

Mad Pianist, 1955–6, 2nd state of 2
Etching and engraving, 117 x 167 mm [Cat.7]

Finale, 1955–6, 2nd state of 3
Etching, engraving and drypoint, 147 x 198 mm [Cat.6]

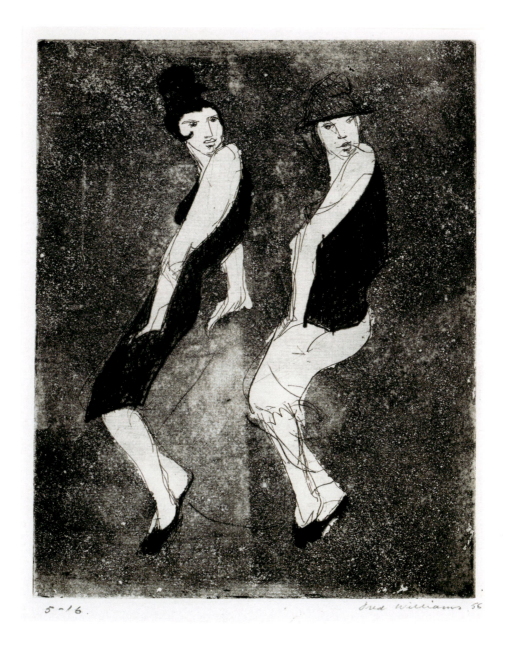

'The Boy Friend', 1955–6, 1st state of 2
Etching, aquatint, engraving and drypoint, 200 x 163 mm [Cat.17]

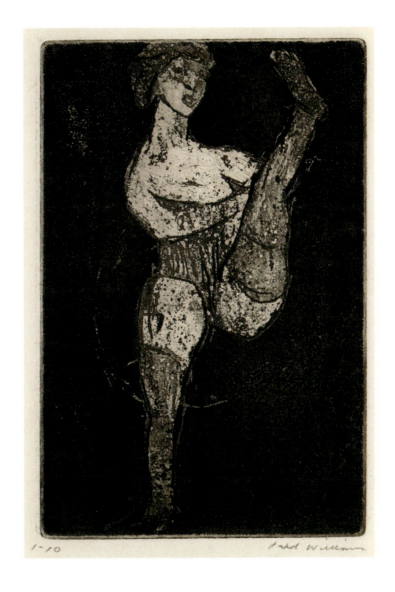

The Can Can, 1955–6, 2nd state of 2
Etching, aquatint and engraving, 149 x 101 mm [Cat.13]

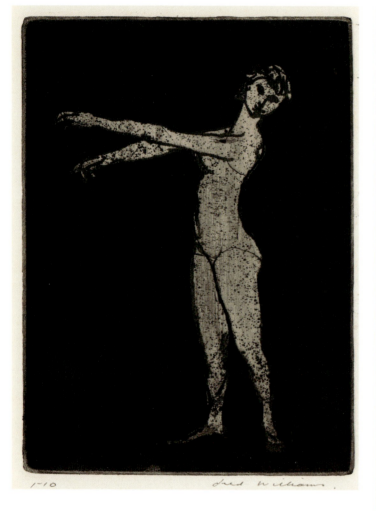

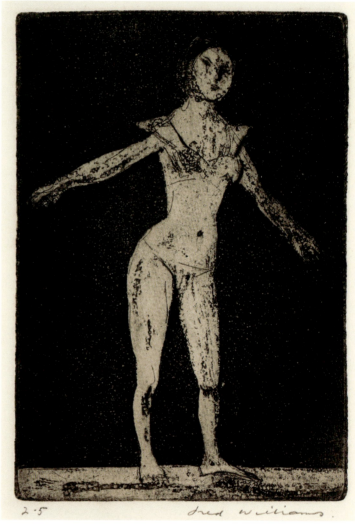

Acrobat, 1955–6, 1st state of 2
Etching and aquatint, 161 x 121 mm [Cat.15]

Dancer, 1955–6, 5th state of 6
Etching, aquatint and drypoint, 147 x 102 mm [Cat.14]

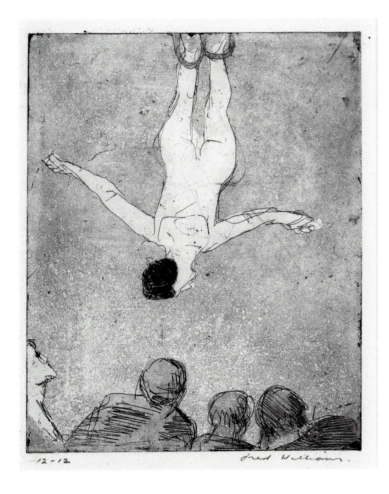

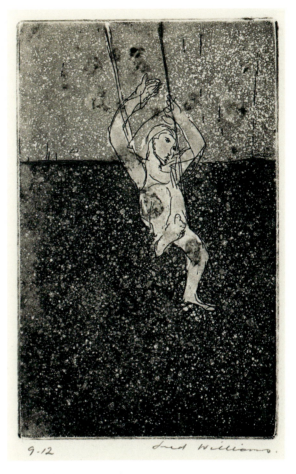

Trapeze, 1955–6, 2nd state of 4
Etching, aquatint and drypoint, 200 x 163 mm [Cat.16]

Swinging, 1955–6, 1st state of 2
Etching, aquatint, engraving and rough biting, 153 x 99 mm [Cat.12]

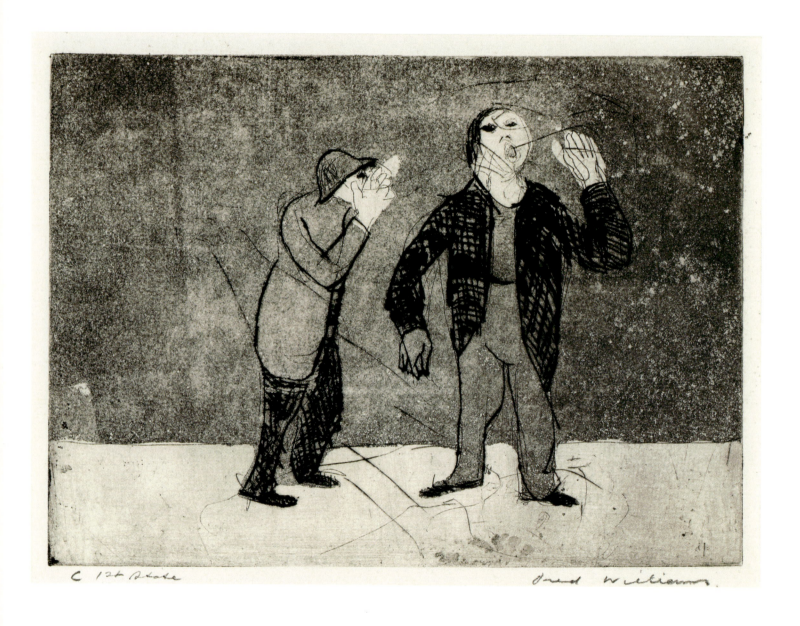

Two Actors on Stage, 1955–6, 1st state of 3 before plate cut
Etching, aquatint and drypoint, 124 x 174 mm [Cat.8]

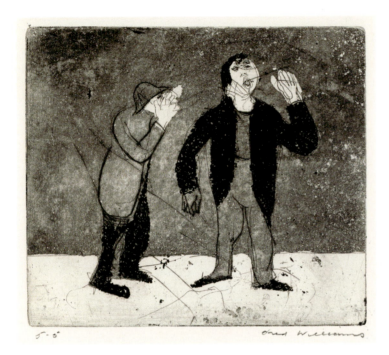 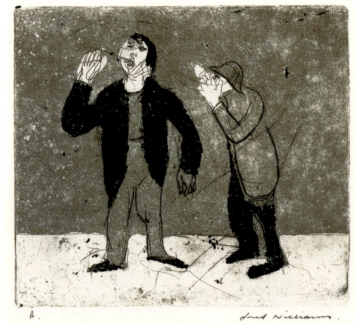

Two Actors on Stage, 1955–6, 3rd state of 3
Etching, aquatint and drypoint, 125 x 145 mm [Cat.9]

Two Actors on Stage, 1955–6, counterproof of final state
Etching, aquatint and drypoint, 125 x 144 mm [Cat.10]

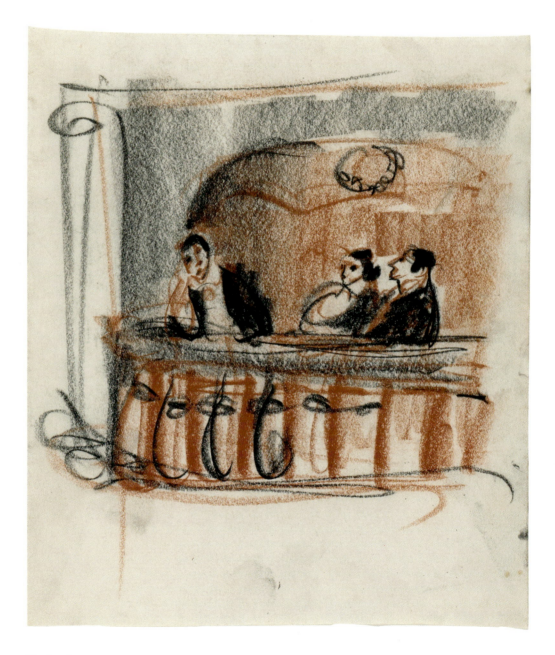

The Angel at Islington, *c.*1952–4
Conté crayon and charcoal on paper, 241 x 209 mm [Cat.81]

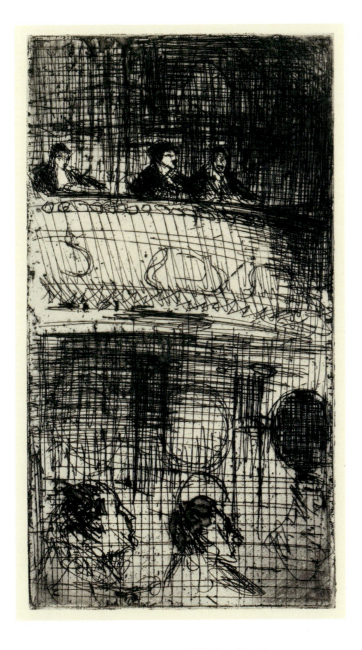

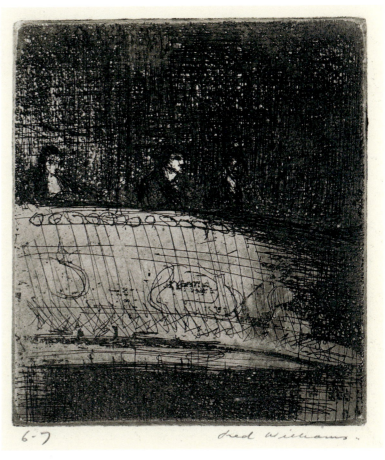

The Angel at Islington, 1955–6, 1st state of 4 before plate cut
Etching, aquatint, drypoint and open bite, 175 x 96 mm [Cat.4]

The Angel at Islington, 1955–6, 3rd state of 4
Etching, aquatint, drypoint and open bite, 106 x 96 mm [Cat.5]

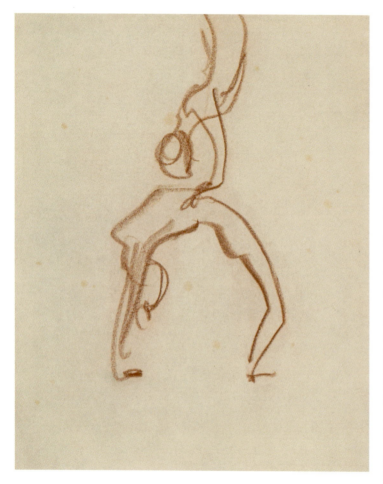

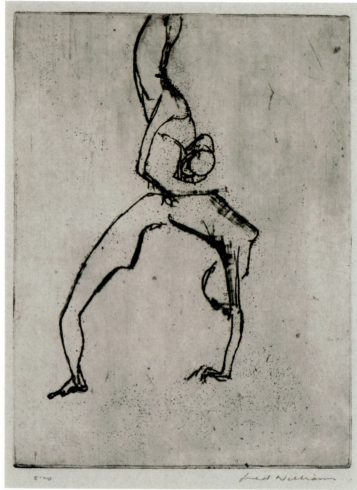

Tumblers, *c*.1953–4
Conté crayon on paper, 265 x 209 mm [Cat.82]

Tumblers Number 2, 1967, 1st state of 5
Deep etching, 254 x 193 mm [Cat.19]

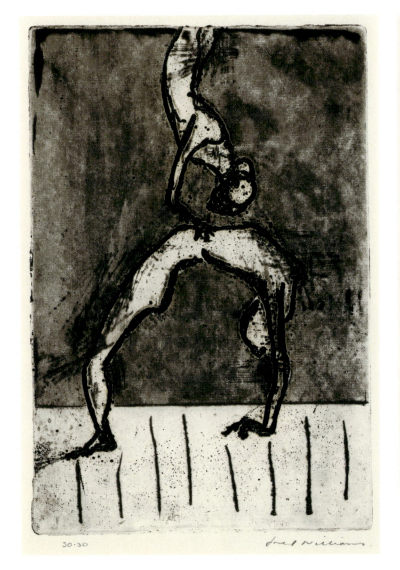

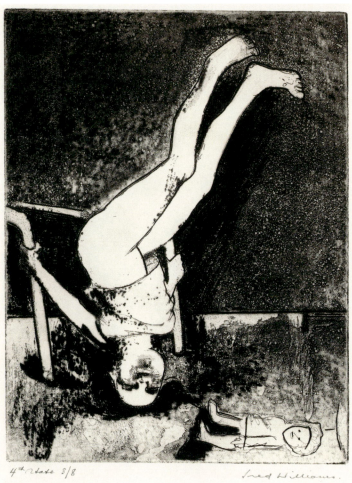

Tumblers Number 2, 1967, 5th state of 5
Etching, deep etching, and flat biting with rocker, 253 x 173 mm [Cat.20]

Kate Watching TV, 1974, 4th state of 5
Aquatint, drypoint, and engraving with electric hand engraving tool and roulette, 256 x 201 mm [Cat.73]

Homecoming and the First Landscape Prints

Landscape Triptych Number 1, 1962
[Cat.34, p.69] (detail)

'Well Freddy, what are you going to do?'
'I am going to paint the gum tree.'
'You can't do that. Everybody's done that.'
'Well it's just what I'm going to do.'

Exchange between Fred Williams and John Brack, on Williams's return to Melbourne in January 1957, recalled by Hal Hattam in an interview with James Mollison, 1 April 1987 (Mollison 1989, p. 35)

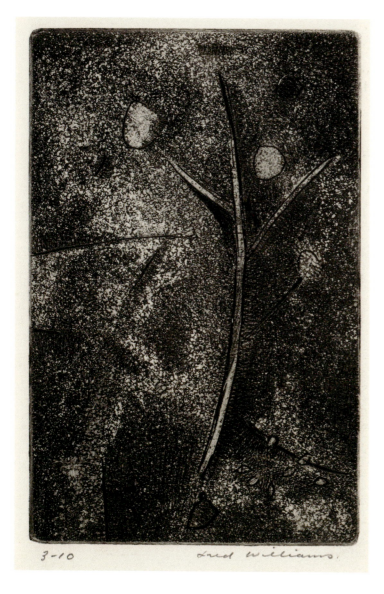

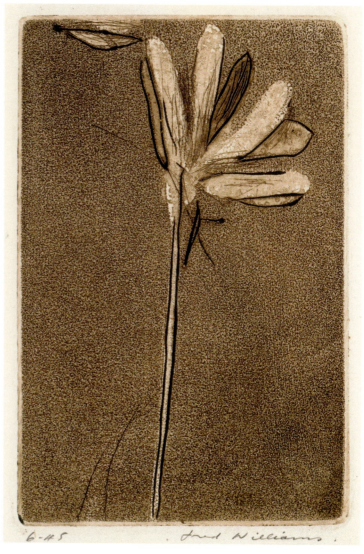

Gum Tree, 1958, 3rd state of 4
Aquatint, engraving, rough biting and drypoint, 149 x 99 mm [Cat.21]

Hakea, 1963, 4th state of 5
Etching, aquatint and drypoint in sepia, 135 x 90 mm [Cat.18]

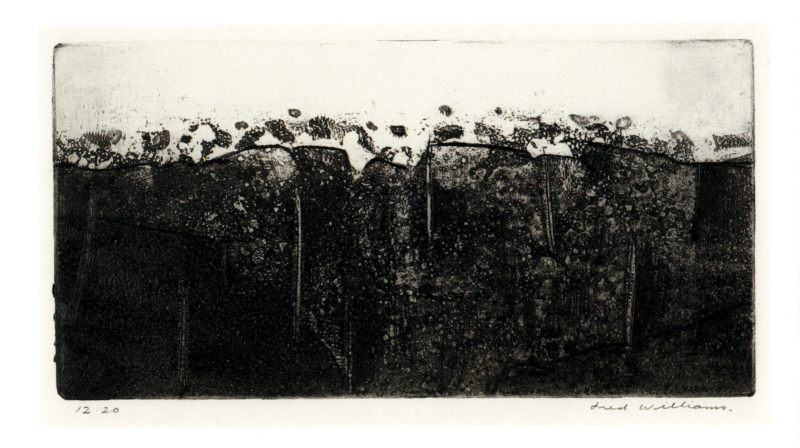

12.20 fred Williams.

Sandstone Hill Number 1, 1961, 1st state of 2
Aquatint, engraving and drypoint, 105 x 212 mm [Cat. 26]

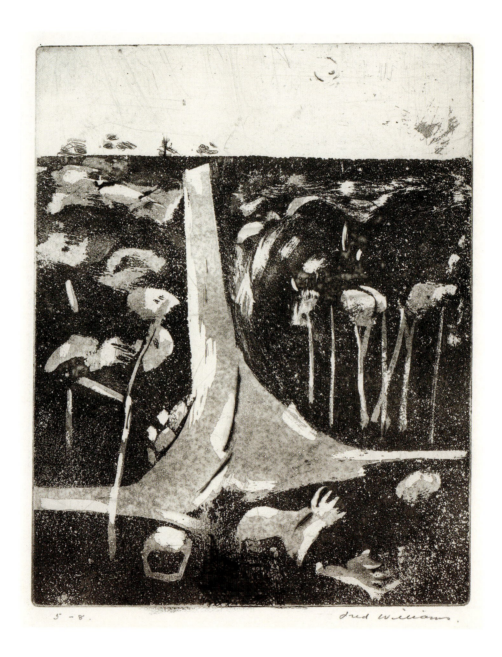

Landscape with a Steep Road, 1959, 3rd state of 5
Aquatint, etching, drypoint and engraving, 196 x 157 mm [Cat.24]

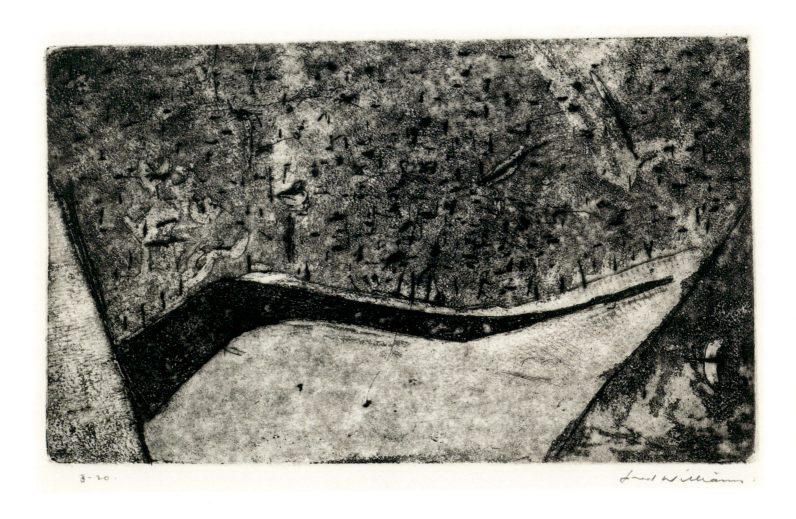

The St George River, Lorne, 1959–60, 4th state of 4 (completed in 1966)
Etching, aquatint, engraving and drypoint, 162 x 277 mm [Cat.25]

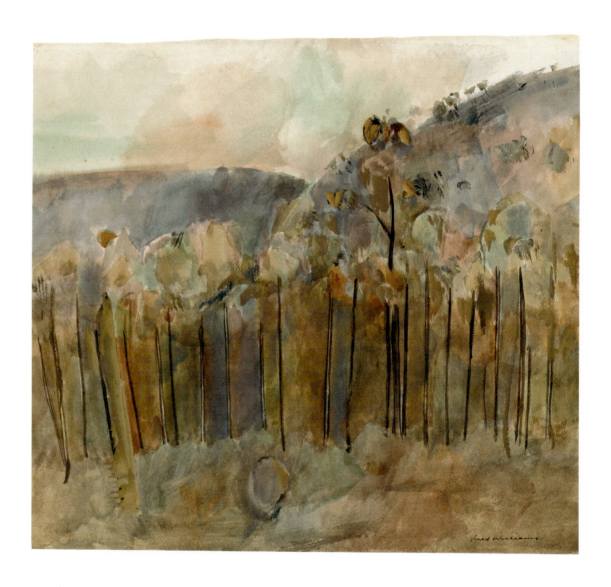

Saplings, Mittagong, 1962
Watercolour on paper, 385 x 420 mm [Cat.83]

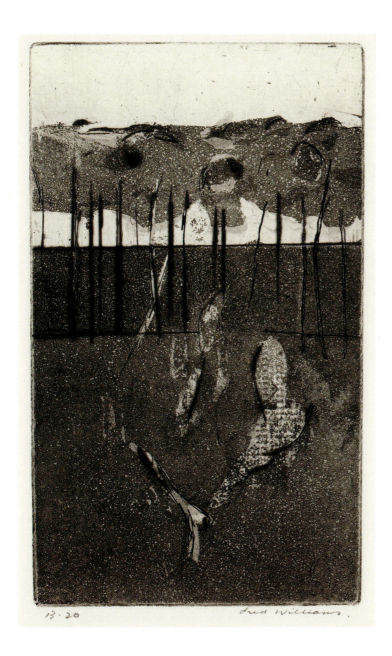

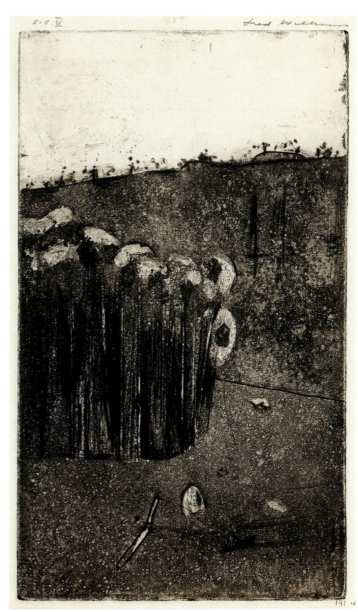

Burning Log, 1958–9, 2nd state of 3
Aquatint, engraving, etching and drypoint, 212 x 129 mm [Cat.23]

Saplings, 1962, 4th state of 9
Aquatint, drypoint and engraving, 246 x 148 mm [Cat.33]

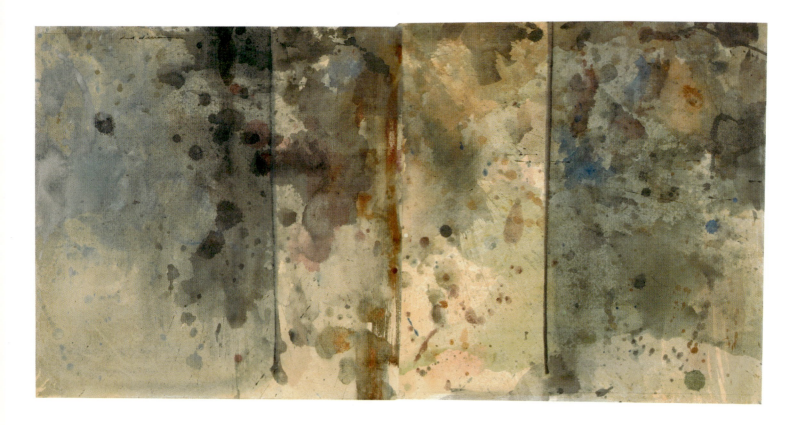

Forest Diptych, 1962
Watercolour on two sheets of paper, 365 x 731 mm (overall) [Cat.85]

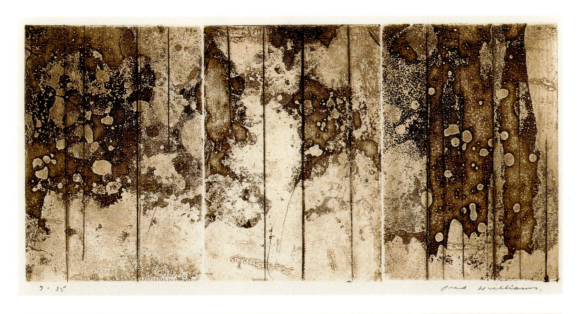

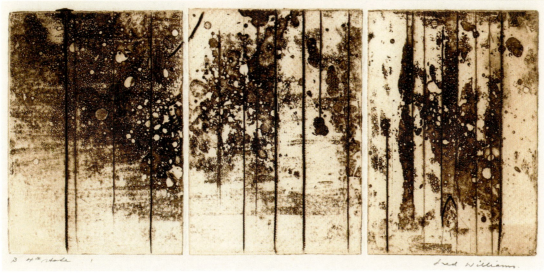

Top: **Landscape Triptych Number 1**, 1962, 2nd state of 4
Three plates printed side by side on one sheet
Sugar aquatint, engraving and drypoint in sepia, 122 x 271 mm (overall) [Cat.34]

Above: **Landscape Triptych Number 2**, 1962, 4th state of 5
Three plates printed side by side on one sheet
Aquatint, engraving and drypoint in sepia, 127 x 282 mm (overall) [Cat.35]

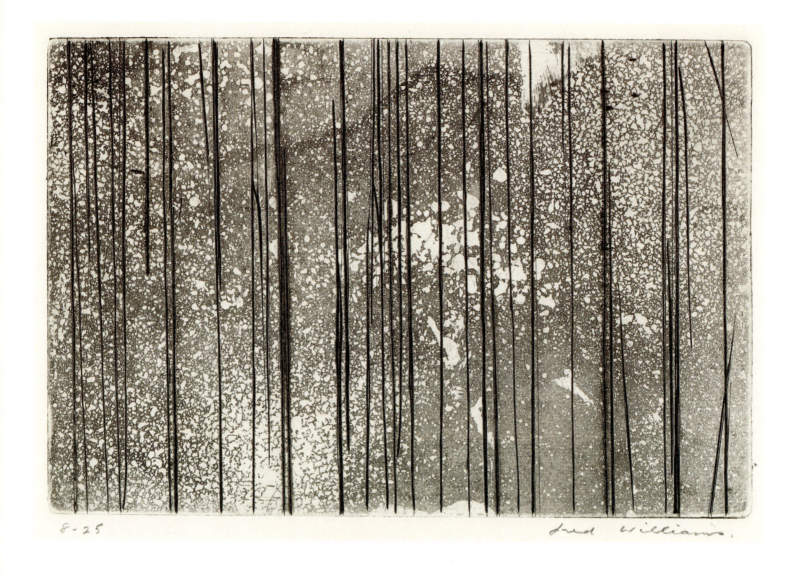

8·25 fred williams.

Sapling Forest, 1961, 2nd state of 4
Aquatint, engraving and drypoint, 132 x 201 mm [Cat.27]

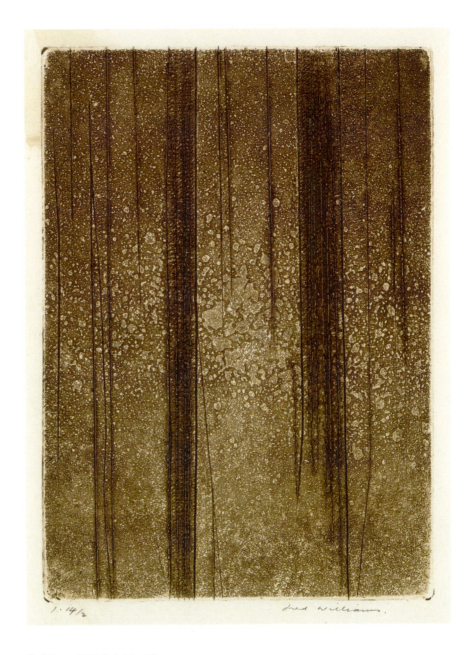

Red Trees, 1958, 2nd state of 3
Etching, aquatint and drypoint in sepia, 201x 147 mm [Cat.22]

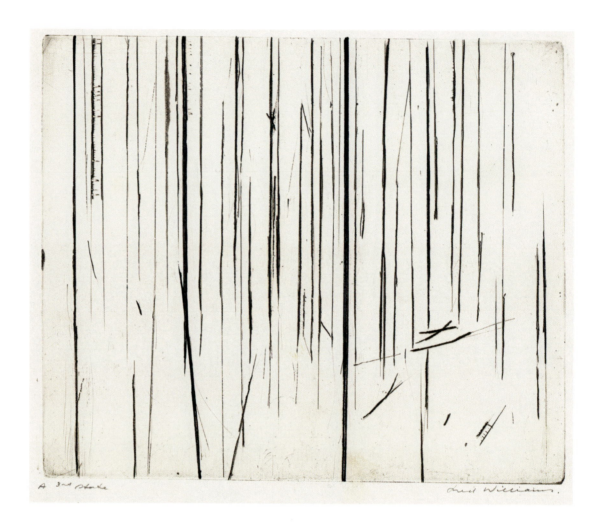

Echuca Landscape, 1961, 3rd state of 16
Engraving, 157 x 191 mm [Cat.28]

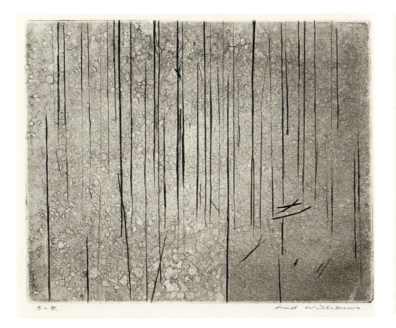 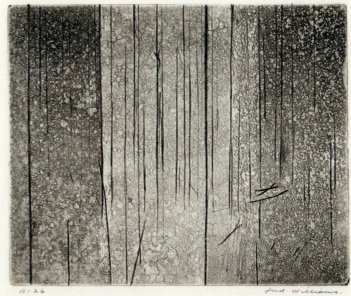

Echuca Landscape, 1961, 7th state of 16
Engraving and aquatint, 153 x 193 mm [Cat.29]

Echuca Landscape, 1963, 13th state of 16
Engraving, aquatint and drypoint, 154 x 193 mm [Cat.30]

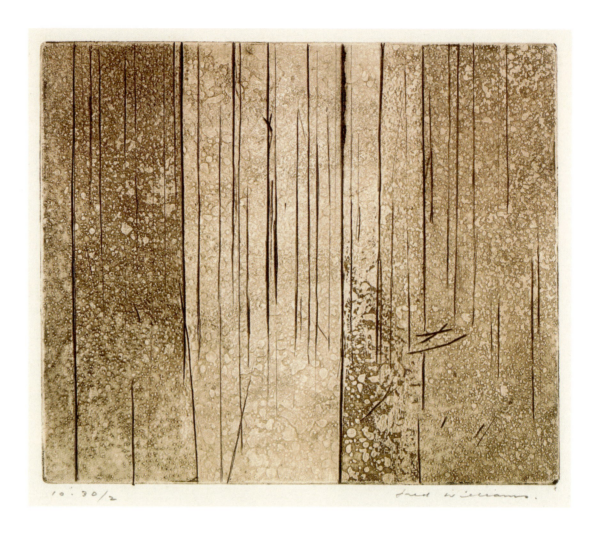

Echuca Landscape, 1963, 15th state of 16
Engraving, aquatint and drypoint in sepia, 157 x 190 mm [Cat.31]

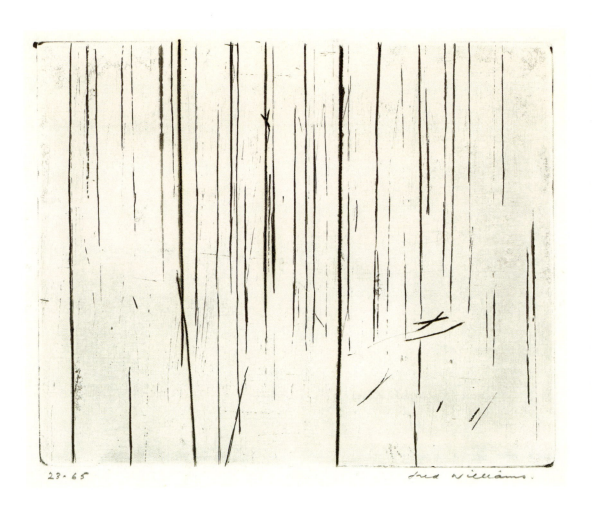

Echuca Landscape, 1963, 16th state of 16
Engraving and drypoint, 154 x 194 mm [Cat.32]

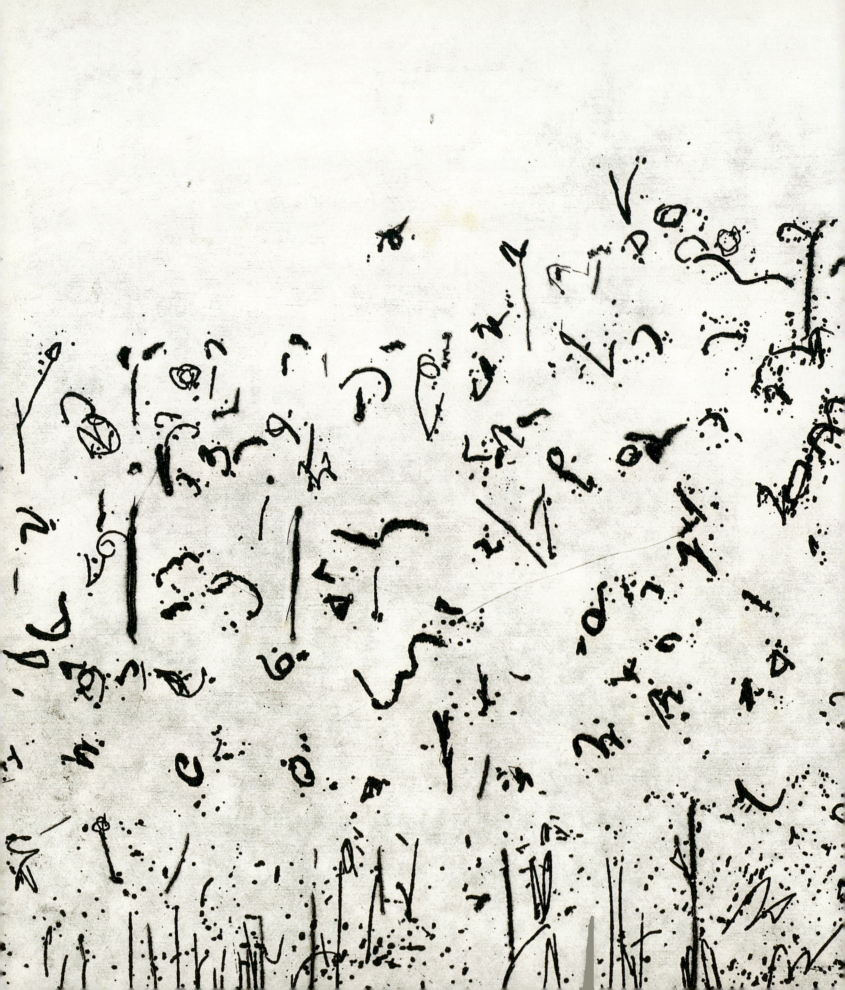

The Essential Landscape

Hillside at Lysterfield, 1965–6
[Cat.52, p.94] (detail)

'It's perfectly true, [the Australian landscape] is monotonous…There is no focal point, and obviously it was too good a thing for me to pass up…the fact [that] if there's going to be no focal point in a landscape [then] it had to [be built] into the paint…'

Fred Williams to James Gleeson, interview 3 October 1978 for Australian National Gallery Interview Series

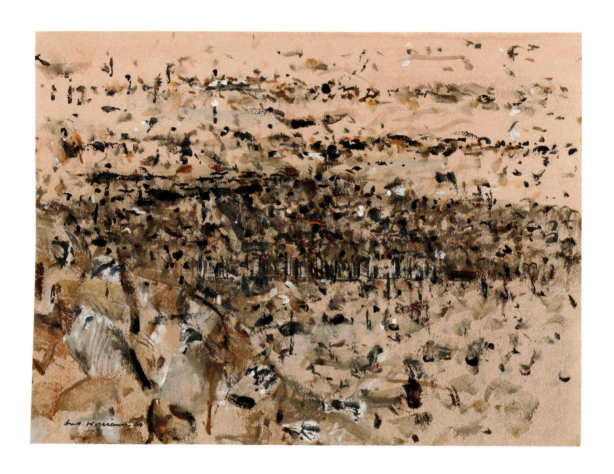

You Yangs Landscape, 1962
Gouache, watercolour and chalk on pink prepared paper, 342 x 470 mm [Cat.84]

You Yangs Series, 1963
Black, sienna, ochre and white conté on Kent paper, 760 x 560 mm [Cat.86]

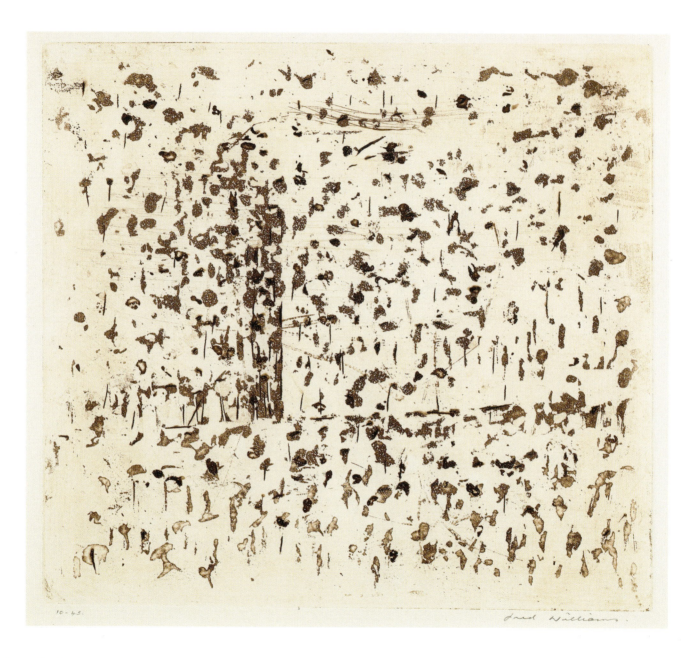

You Yangs Landscape Number 1, 1963, 4th state of 5
Aquatint, engraving and drypoint in sepia, 272 x 303 mm [Cat.36]

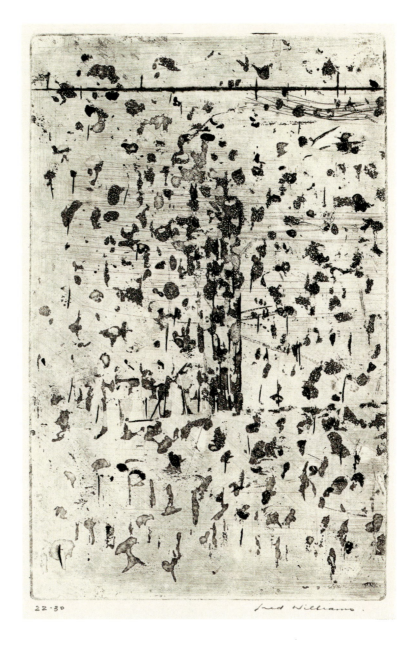

You Yangs Landscape Number 1, 1964, 5th state of 5 after plate cut
Aquatint, engraving and drypoint, 278 x 181 mm [Cat.37]

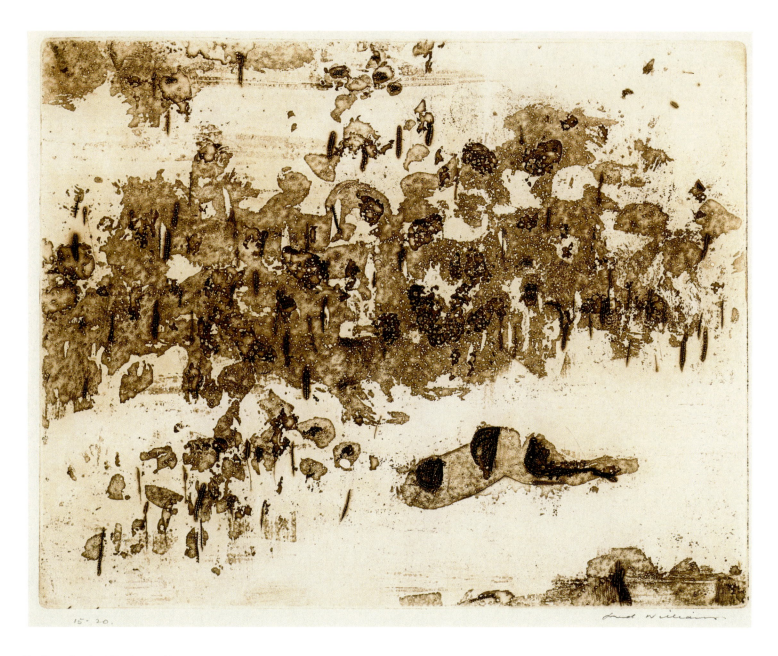

You Yangs Pond, 1963, 4th state of 8
Etching, aquatint, engraving and drypoint in sepia, 235 x 301 mm [Cat.38]

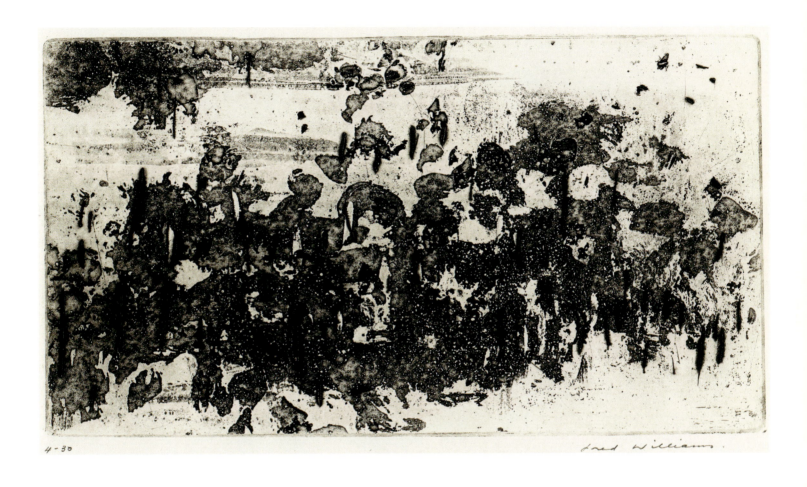

You Yangs Pond, 1964, 8th state of 8 after plate cut, removing pond
Etching, aquatint, engraving and drypoint, 161 x 300 mm [Cat.39]

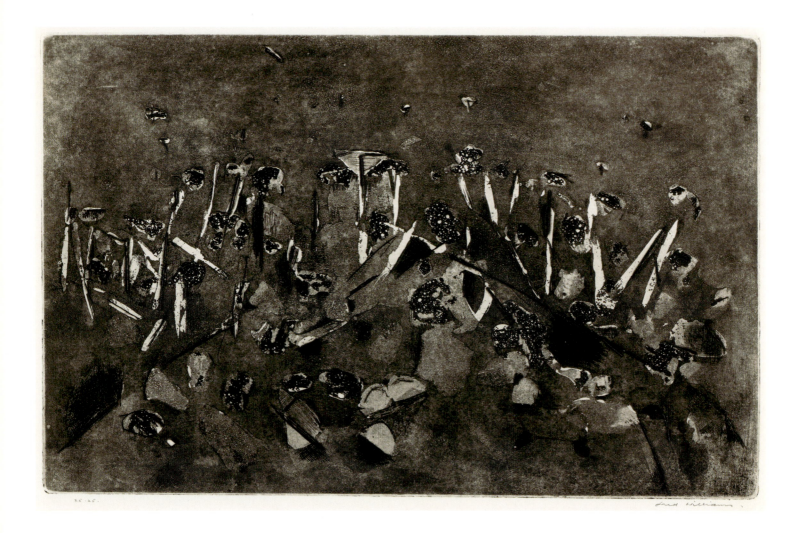

Knoll in the You Yangs, 1963, 16th state of 17
Aquatint, engraving and drypoint, 295 x 456 mm [Cat.40]

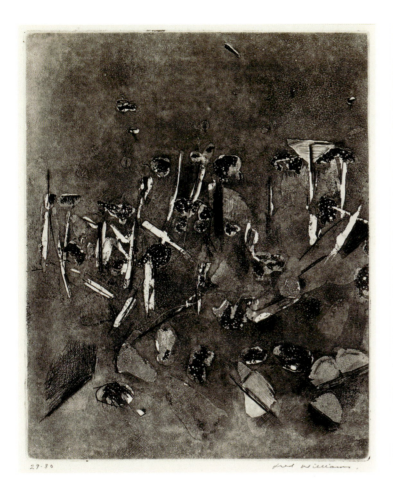

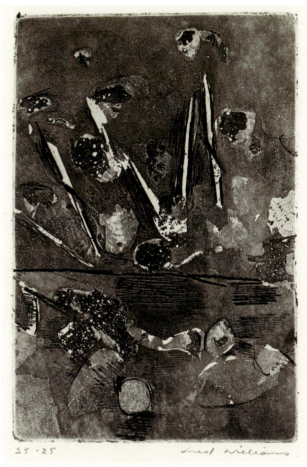

Knoll in the You Yangs, 1964, 17th state (A) of 18 after plate cut in two,
with this being the former left half of the plate
Aquatint, engraving and drypoint, 246 x 298 mm [Cat.41]

Knoll in the You Yangs, 1964, 17th state (B) of 18 after plate cut in two,
with this being a piece from the former right half of the plate
Aquatint, engraving and drypoint, 191 x 132 mm [Cat.42]

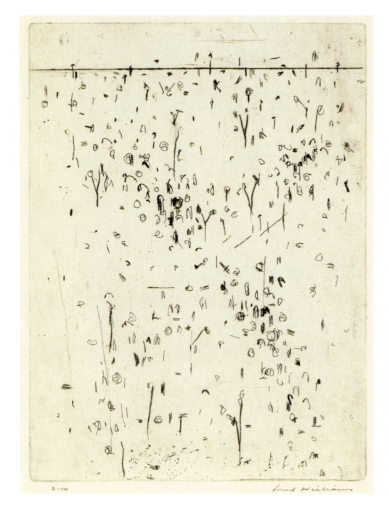

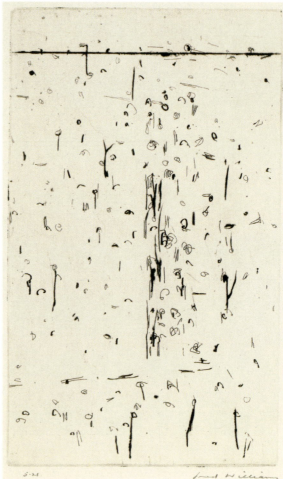

You Yangs Landscape Number 2, 1966, 5th state of 5
Etching, engraving and drypoint, 266 x 203 mm [Cat.43]

First Variation of You Yangs Landscape Number 1, 1965–6, 3rd state of 3
Etching, engraving and drypoint, 265 x 162 mm [Cat.44]

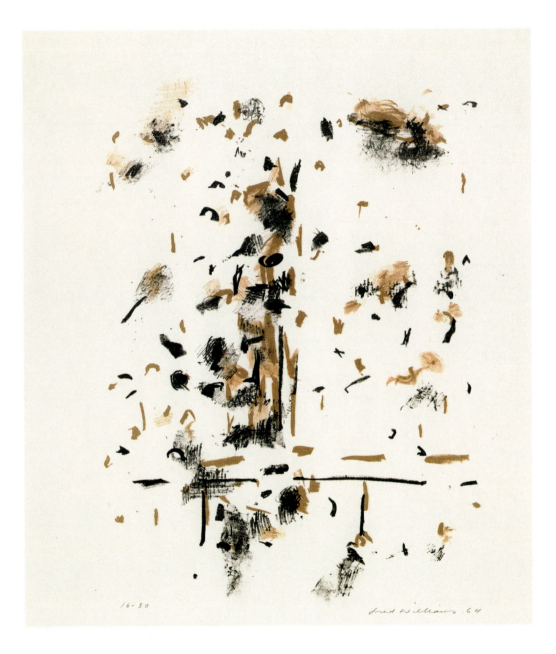

16-30 Fred Williams .64

You Yangs Landscape, 1964
Lithograph in brown and black, 310 x 242 mm [Cat.80]

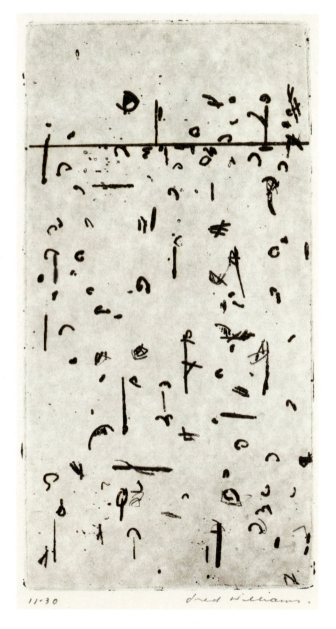

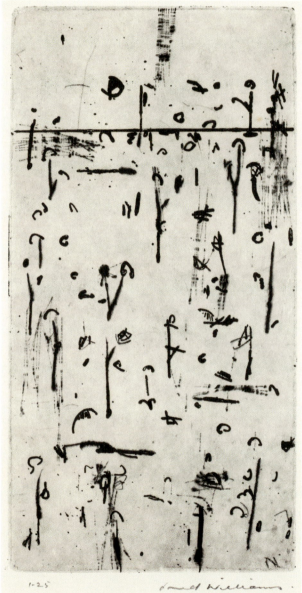

Decorative Panel, You Yangs Number 3, 1965–6, 1st state of 2
Etching, engraving and flat biting, 200 x 105 mm [Cat.45]

Decorative Panel, You Yangs Number 3, 1965–6, 2nd state of 2
Etching, engraving, flat biting and mezzotint rocker, 201 x 105 mm [Cat.46]

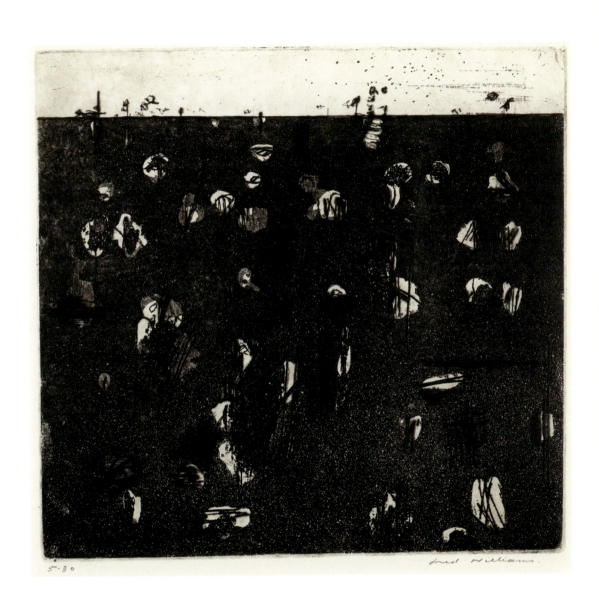

Landscape with Green Cloud and Owl, 1965–6, 1st state of 2
Etching and aquatint, 248 x 267 mm [Cat.50]

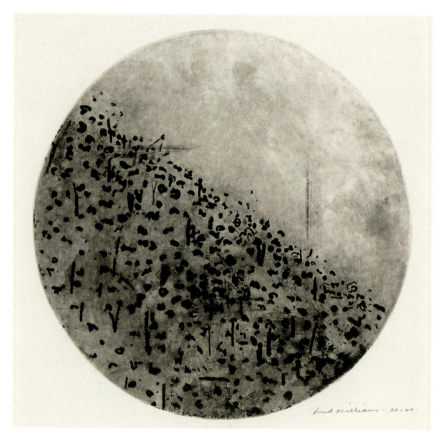

Circle Landscape, Upwey, 1965–6, 4th state of 5
Etching, aquatint and drypoint, 284 mm (diam.) [Cat.47]

Oval Landscape, 1965–6, 4th state of 5
Sugar aquatint, engraving and drypoint, 298 x 184 mm [Cat.53]

Hillside Number 1, 1965–6, 2nd state of 3
Etching, aquatint and drypoint, 198 x 213 mm [Cat.49]

Gum Trees in Landscape, Lysterfield, 1965–6, 3rd state of 4
Etching, aquatint, sugar aquatint and drypoint, 270 x 181 mm [Cat.48]

Chopped Trees, Lysterfield, 1966–7, only state
Etching, aquatint, drypoint and flat biting, 248 x 392 mm [Cat.54]

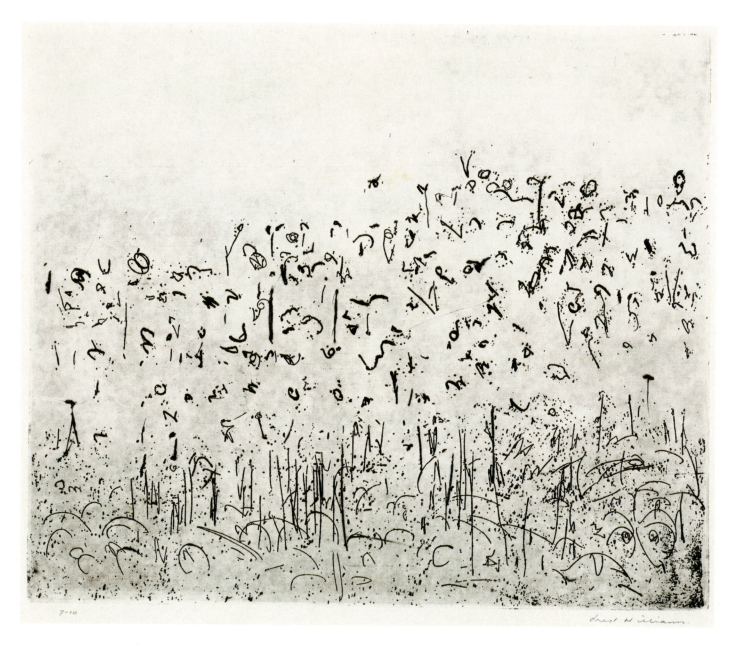

Hillside at Lysterfield, 1965–6, 5th state of 5
Etching, engraving, drypoint and flat biting, 288 x 353 mm [Cat.52]

94

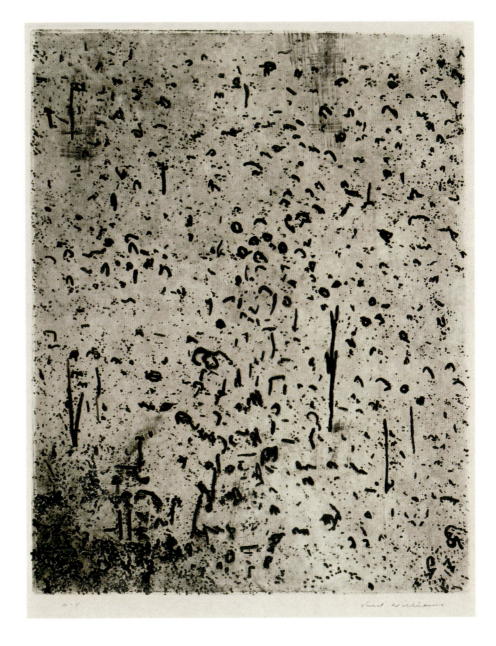

Forest of Gum Trees, 1965–6, 4th state of 4
Etching and flat biting with rocker, 342 x 274 mm [Cat.51]

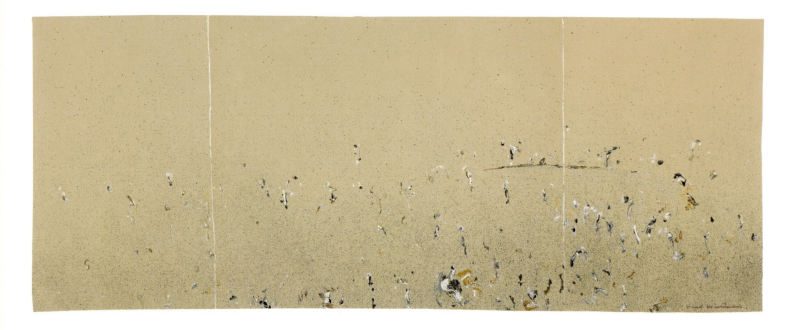

Australian Landscape No. 10, 1969
Gouache on Arches paper, 283 x 719 mm (image) [Cat.87]

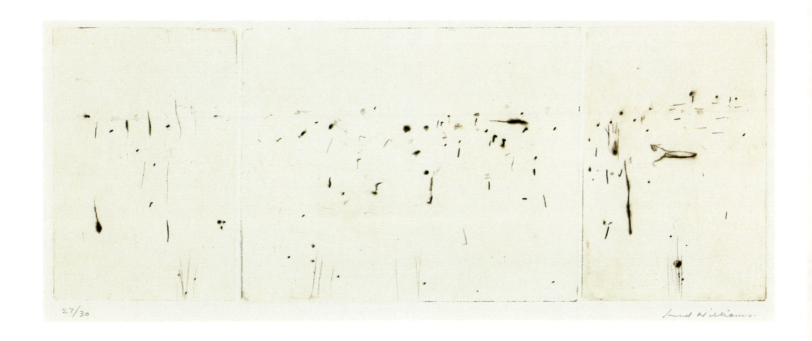

27/30 Fred Williams

Canberra Triptych (Lysterfield), 1970, 2nd state of 2
Three plates printed side by side on one sheet
Etching and drypoint in dark brown, 202 x 540 mm (overall) [Cat.55]

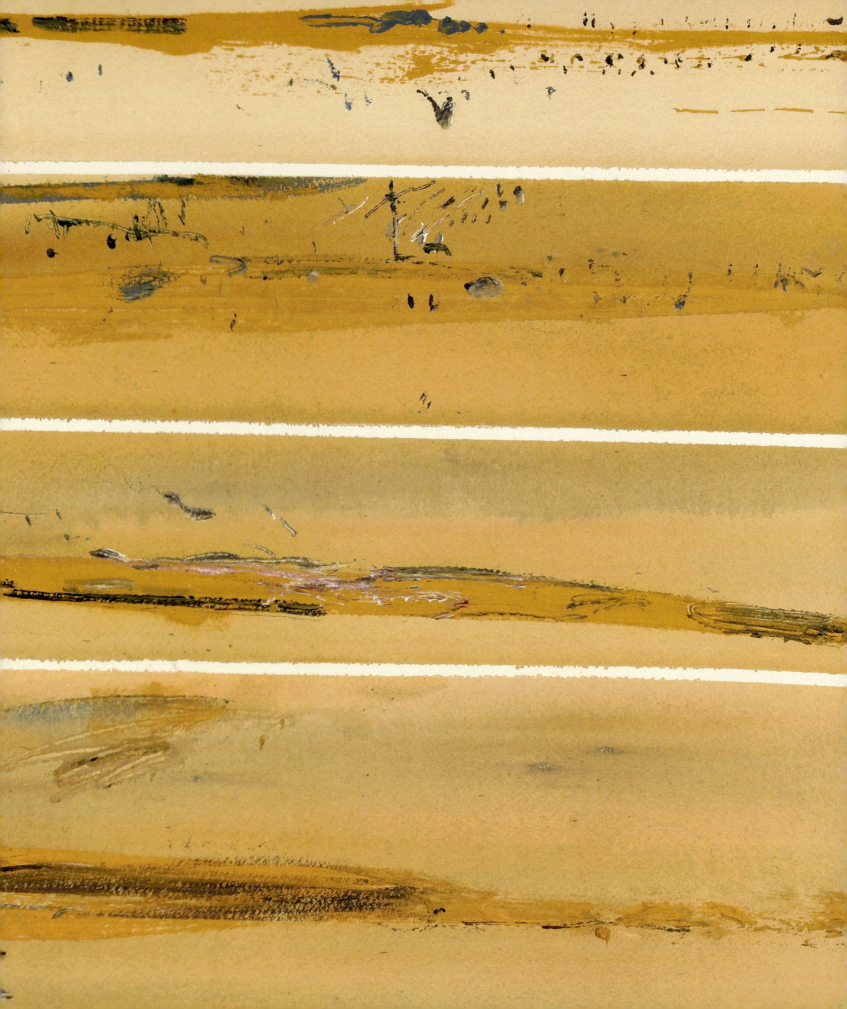

A Vision Cut Short

Bega No. 3, 1975 [Cat.89, p.108] (detail)

'…I only use the subject matter as an excuse to hang the picture on.'

Fred Williams, *Diary*, 5 July 1970

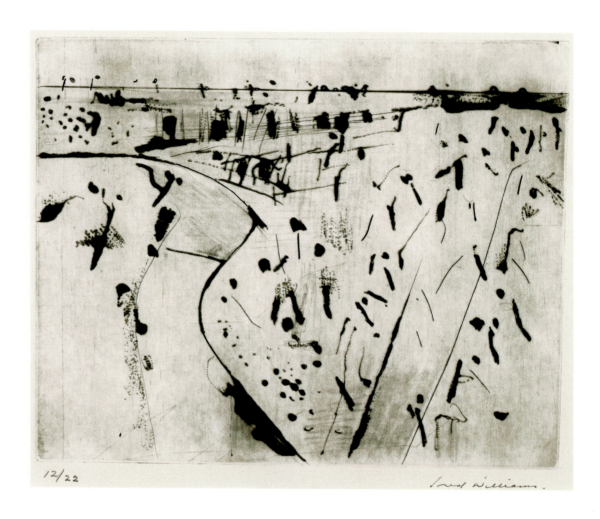

12/22 Fred Williams.

Plenty Gorge, 1973, 4th state of 4
Drypoint and engraving with electric hand engraving tool, roulette and scraping,
221x 285 mm [Cat.70]

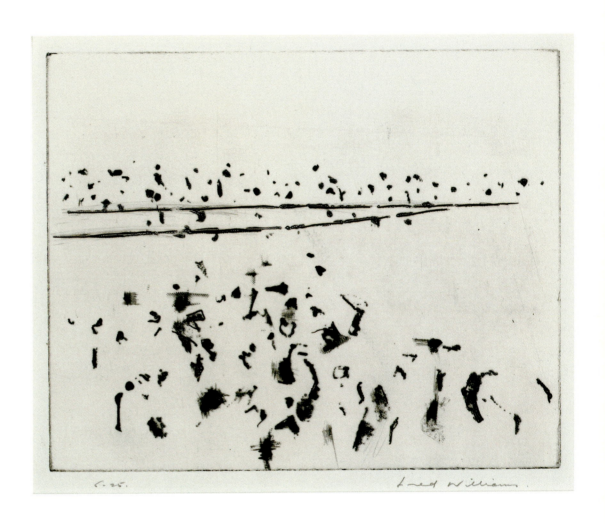

Silver and Grey Landscape, 1971, 3rd state of 3
Drypoint with electric hand engraving tool and roulette, 202 x 255 mm [Cat.57]

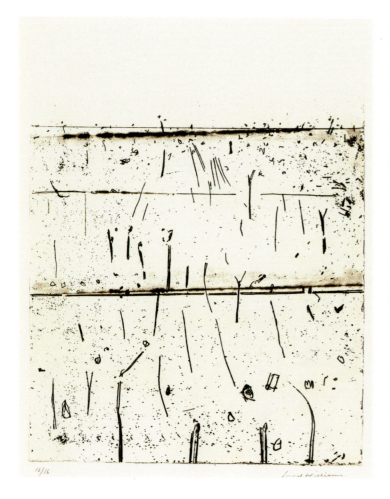 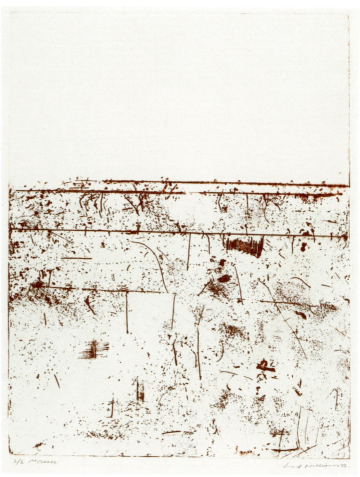

Lysterfield Number 1, 1972, 4th state of 4
Etching and engraving with electric hand engraving tool and roulette in dark brown,
453 x 350 mm [Cat.58]

Lysterfield Number 2, 1972, 1st state of 2
Etching and engraving with electric hand engraving tool and roulette in red ochre,
449 x 355 mm [Cat.59]

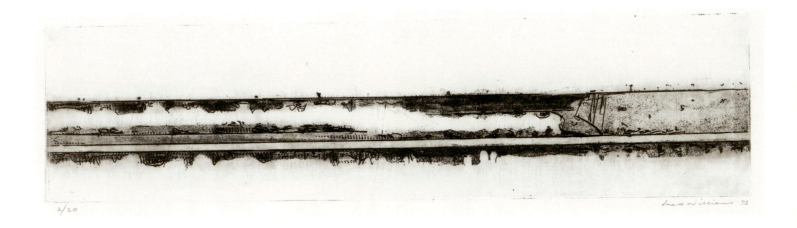

Panel 1, Murray River, Number 1, 1972, 2nd state of 2
Etching with roulette and foul biting, 138 x 548 mm [Cat 60]

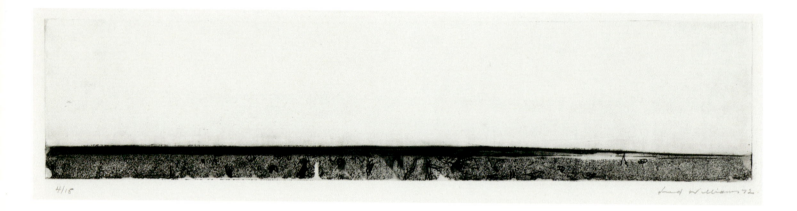

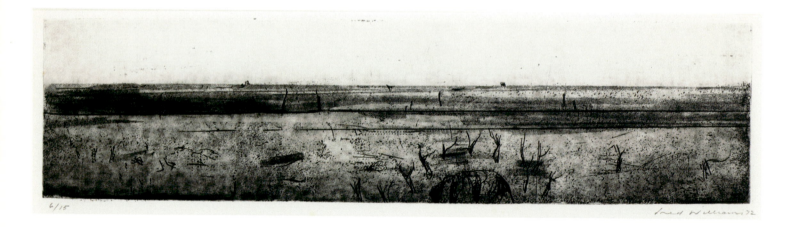

Top: **Panel 2, Murray River, Number 2**, 1972, 2nd state of 2
Etching with roulette and foul biting, 120 x 548 mm [Cat.61]

Above: **Panel 3, Murray River, Number 3**, 1972–3, 1st state of 2
Etching and engraving with roulette and foul biting, 138 x 556 mm [Cat.62]

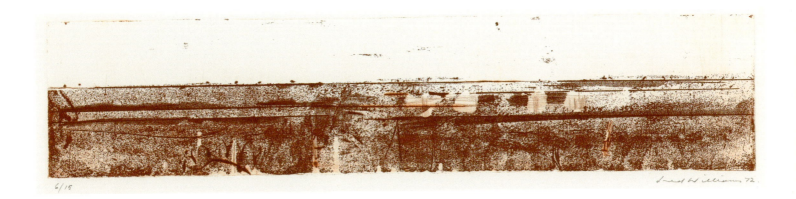

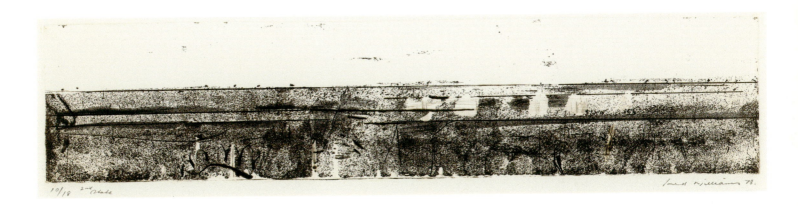

Top: **Panel 4, Murray River, Number 4**, 1972–3, 3rd state of 4
Etching, drypoint and engraving with mezzotint rocker, electric hand engraving tool
and roulette in sanguine, 119 x 555 mm [Cat.63]

Above: **Panel 4, Murray River, Number 4**, 1972–3, 4th state of 4
Etching, drypoint and engraving with mezzotint rocker, electric hand engraving tool
and roulette, 119 x 555 mm [Cat.64]

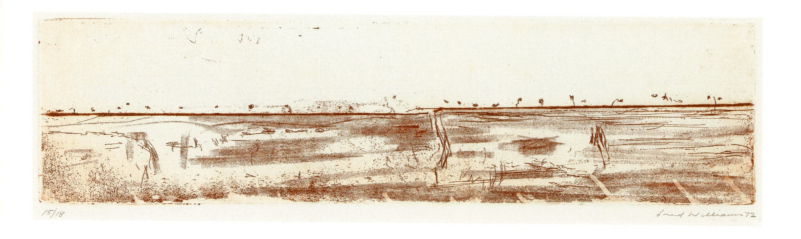

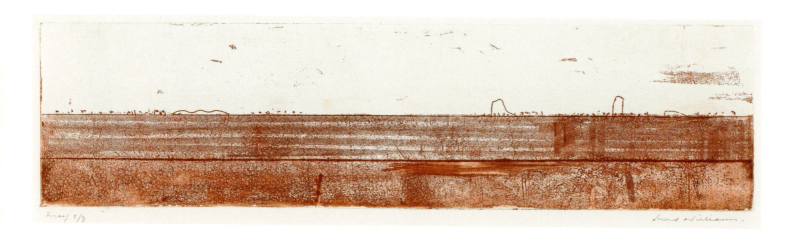

Top: **Panel 5, Murray River, Number 5**, 1972, 2nd state of 2
Etching and engraving with foul biting and roulette in sanguine, 138 x 555 mm [Cat.65]

Above: **Panel 6, Glass House Mountains**, 1972, 2nd state of 2
Etching, aquatint, drypoint and engraving with foul biting and roulette in sanguine,
139 x 550 mm [Cat.66]

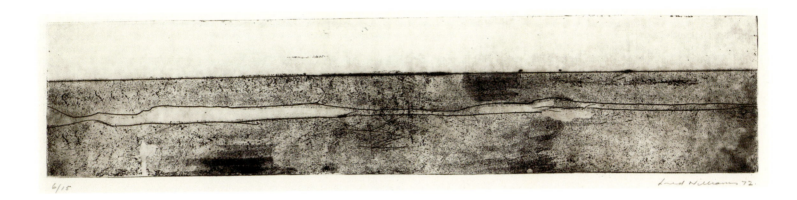

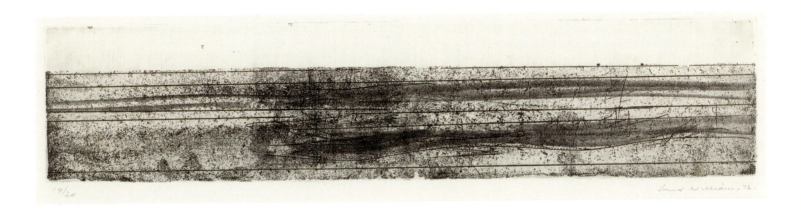

Top: **Panel 7, Cannons Creek**, 1972, 2nd state of 2
Etching and engraving with foul biting and roulette, 119 x 556 mm [Cat.67]

Above: **Panel 8, Murray River Number 6**, 1972, only state
Etching with foul biting and roulette, 119 x 555 mm [Cat.68]

107

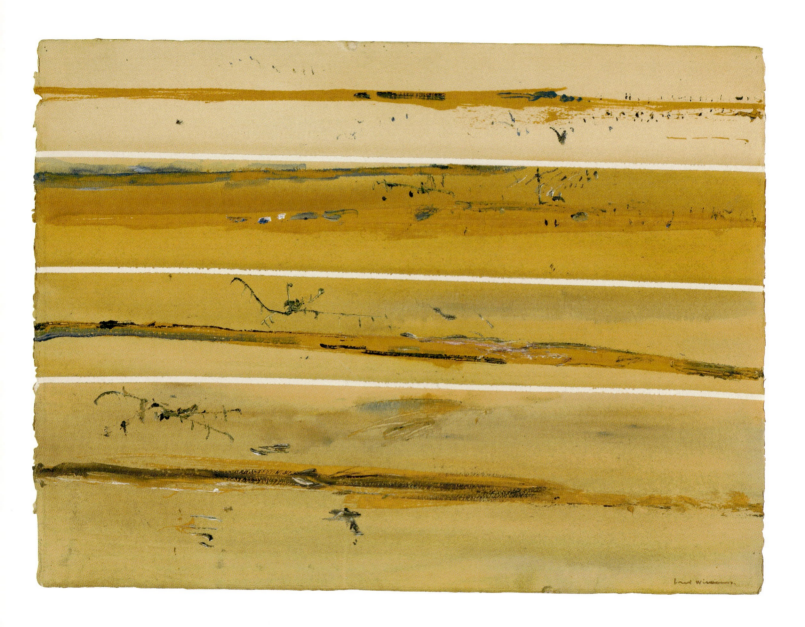

Bega No. 3, 1975
Gouache on Arches paper, 564 x 775 mm [Cat.89]

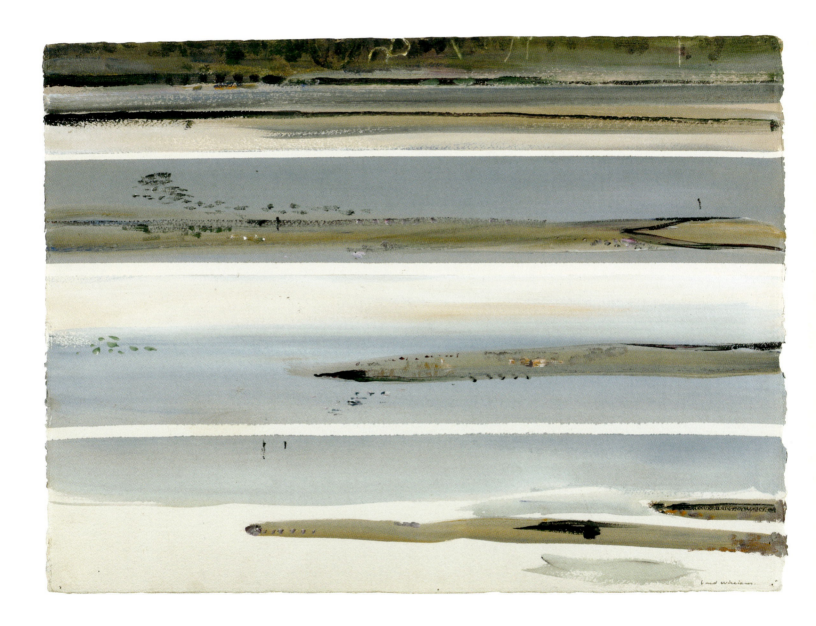

Bega No. 1, 1975
Gouache on Arches paper, 564 x 775 mm [Cat.88]

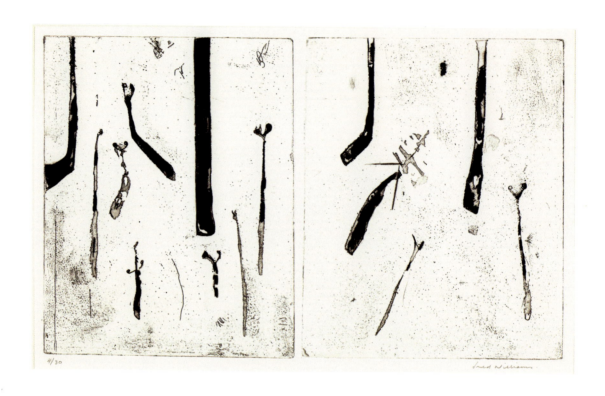

Ferns Diptych Number 2, 1970, 2nd state of 3
Two plates printed side by side on one sheet
Etching, aquatint and drypoint, 276 x 463 mm (overall) [Cat.56]

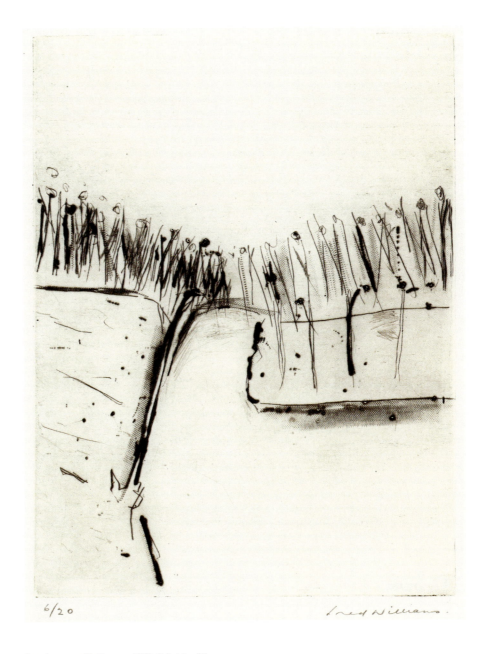

6/20 Fred Williams.

Landscape with Goose, 1973, 3rd state of 3
Drypoint and engraving with electric hand engraving tool and roulette, 255 x 198 mm [Cat.69]

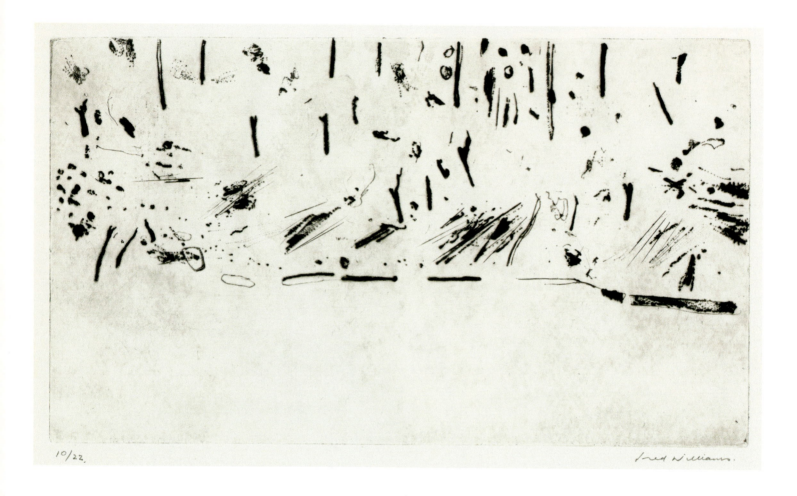

Yellow Landscape '74, 1974, only state
Drypoint and engraving with electric hand engraving tool, 253 x 449 mm [Cat.71]

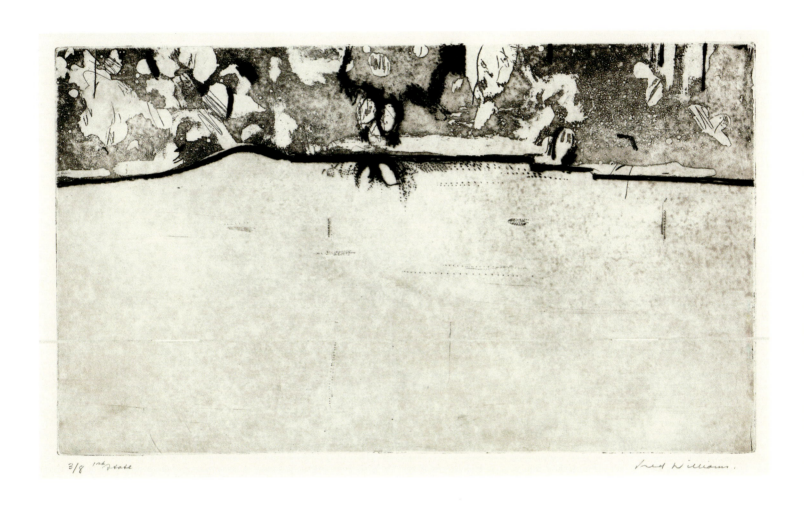

Forest Pond '74, 1974, 2nd state of 2
Aquatint, etching, drypoint and engraving with electric hand engraving tool,
254 x 447 mm [Cat.72]

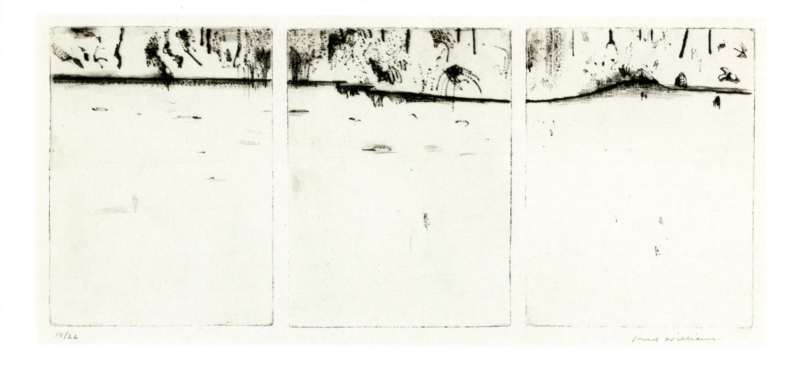

13/26 Fred Williams

Forest Pond Triptych, 1975, 2nd state of 2
Three plates printed side by side on one sheet
Drypoint and engraving with electric hand engraving tool and roulette,
215 x 520 mm (overall) [Cat. 79]

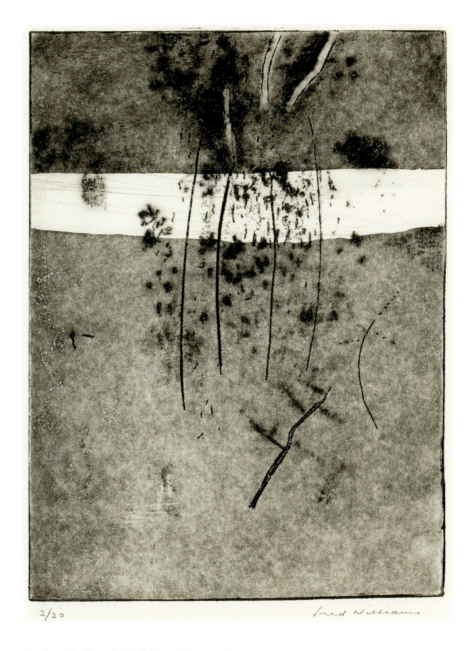

2/20 Fred Williams

Road and Saplings, Cottlesbridge, 1975, only state
Aquatint, drypoint and engraving with electric hand engraving tool and roulette,
300 x 227 mm [Cat.78]

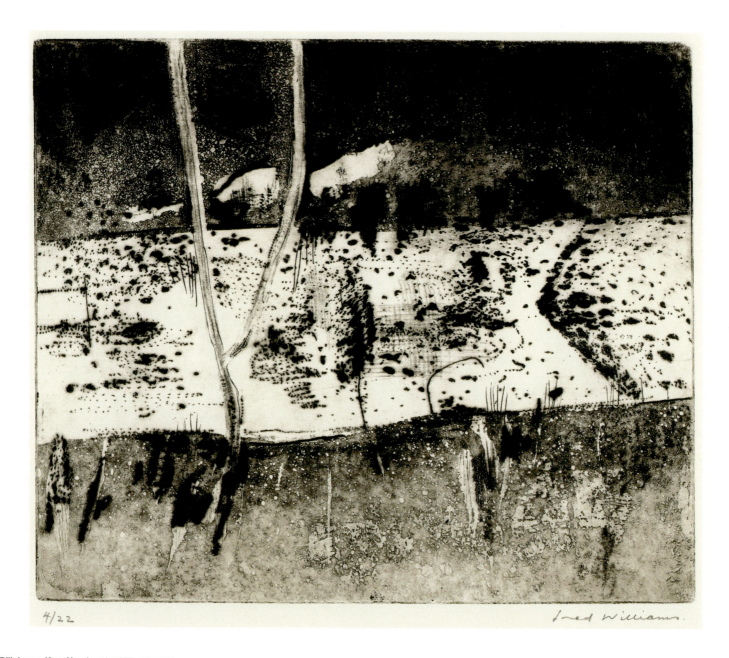

4/22 Fred Williams.

Yarra Billabong, Kew Number 1, 1975, only state
Aquatint, drypoint and engraving with electric hand engraving tool and roulette,
230 x 278 mm [Cat.74]

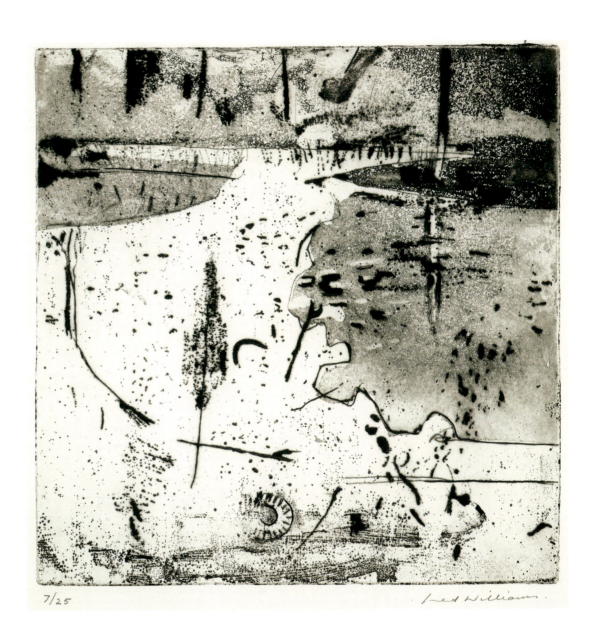

7/25 Fred Williams.

Yarra Billabong, Kew Number 2, 1975, only state
Aquatint, drypoint, engraving with electric hand engraving tool, 290 x 292 mm [Cat.75]

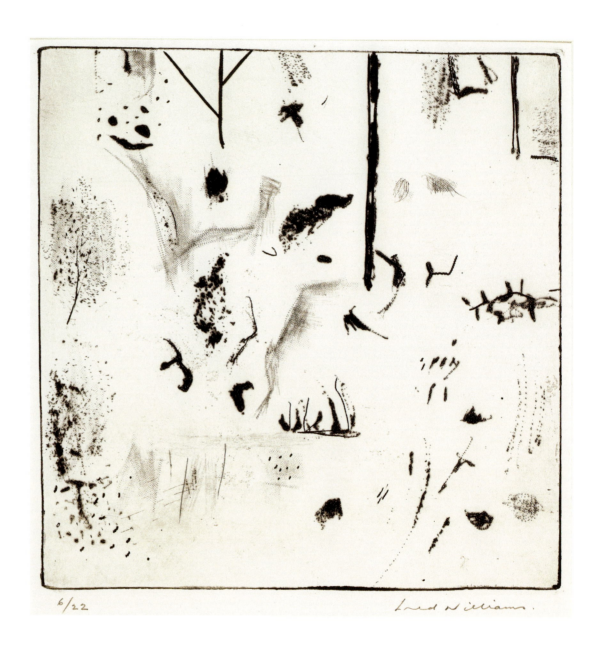

Landscape Symbols, Cottlesbridge, 1975, 2nd state of 2
Drypoint and engraving with electric hand engraving tool and roulette, 248 x 247 mm [Cat.76]

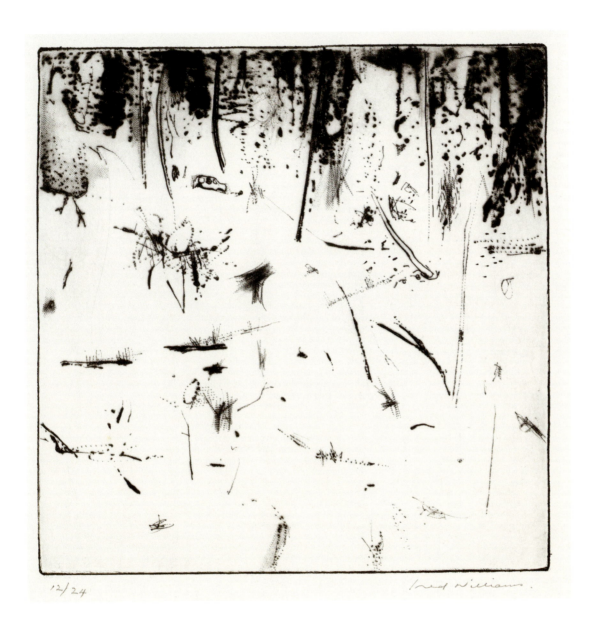

12/24 Fred Williams.

Cottlesbridge, Landscape with Derelict Car, 1975, only state
Drypoint and engraving, with electric hand engraving tool and roulette, 251 x 251mm [Cat.77]

Collecting Australian Prints at the British Museum

by Stephen Coppel

Fig.30 Lionel Lindsay (1874–1961), **Dawn**, 1923, aquatint, 140 x 235 mm (London, British Museum) © Estate of Lionel Lindsay

The recent presentation of seventy etchings and nine drawings, gouaches and watercolours by Fred Williams made by his widow Lyn is the most important gift of work by an Australian artist to have been offered to the British Museum's Department of Prints and Drawings, and lays a firm foundation for the development of a comprehensive collection of graphic works by twentieth-century Australian artists. This is in keeping with the Department's long-standing policy, from the mid-1970s, of developing its twentieth-century collections of prints from Britain and continental Europe, as well as from those parts of the world with close historical and cultural associations with Europe, such as North America, Mexico, Israel, Australia and New Zealand.

The Fred Williams gift provides an opportunity to outline the origins and development of the Department's Australian print collection. The first attempt to form such a collection was initiated in the 1920s by the Department's then Keeper, Campbell Dodgson, working in collaboration with the highly regarded Australian etcher and wood-engraver Lionel Lindsay. The catalyst appears to have been a somewhat conservative exhibition of Australian art shown in London at the Royal Academy in 1923, exemplified by the pastoral landscape paintings of Hans Heysen and Arthur Streeton, in which the stereotypical gum tree was interpreted through the European tradition of Constable, the Barbizon School and a muted form of French Impressionism.[1] An influential admirer of Lionel Lindsay's exhibited wood-engravings was the print scholar and dealer Harold Wright, then director of the print department at Colnaghi's, who later, under the terms of his will and that of his widow, established the Harold Wright scholarship for Australasian scholars to study at the British Museum's Print Room. In 1923, Lindsay presented *A Book of Woodcuts*, 1922, accompanied by twenty-one proofs to the British Museum, and shortly after Campbell Dodgson, who also admired his work, commissioned from him an article on Australian etching for *Print Collector's Quarterly*, of which Dodgson was then editor.[2]

The opportunity of appearing in the leading scholarly journal of the international print world encouraged Lindsay to solicit donations to the British Museum from the Australian artists whose work he was illustrating. Lindsay sent round a circular letter 'to help form the nucleus for a collection of Australian etchings', and among those who responded, in 1924, to Lindsay's appeal were the Adelaide artists John Goodchild, Hans Heysen and Henri Van Raalte, the Sydney etchers A. Henry Fullwood, J. Barclay Godson, Sydney Ure Smith, Lindsay himself and his brother Norman, and from Melbourne, John Shirlow.[3] The twenty-three etchings selected, including the three illustrated here (figs 30–32), were mostly of landscapes, farm buildings, images of people working on the land, or the occasional picturesque city view, although the etchings donated by Norman Lindsay depicted more exotic subject matter, such as Don Juan in hell. Describing Heysen as 'our greatest draughtsman of landscape', Lionel Lindsay praised his proficiency in drawing 'our most difficult tree, the gum, [which] he knows in all its varied forms and effects of light'(fig.32).[4] During this period further additions were also made of etchings by Sydney Long and by Mortimer Menpes, the Australian expatriate and disciple of Whistler. As etching was the most prestigious of the printmaking techniques during the great boom of the 1920s, it is not surprising that those produced by the male bastion of the Australian art establishment should then comprise the core of an Australian print collection at the British Museum.

Entirely absent from the collection are any of the women modernist printmakers of the 1920s and 30s, notably Margaret Preston, Dorrit Black, Eveline Syme, Thea Proctor and Adelaide Perry, all of whom made either woodcuts or linocuts, then deemed of inferior status to etching. A single exception was Ethel Spowers whose linocut, *Wet Afternoon*, 1929, was purchased by Dodgson from the second exhibition of linocuts organized by Claude Flight at the Redfern Gallery in 1930, and later bequeathed by him to the Museum.

During the 1950s and early 60s many Australian artists, including Fred Williams, Arthur Boyd, Sidney Nolan and Brett Whiteley, came to London to further their careers. Australian art was given public exposure through a number of prominent exhibitions beginning in 1953 with the Arts Council of Great Britain's *Twelve Australian Artists*, which the Arts Council's Philip James described as 'the first official exhibition of contemporary Australian painting to be shown in this country',[5] and culminating with the major survey show, *Recent Australian Painting*, organized by Bryan Robertson at the Whitechapel Gallery in 1961, and the Tate's *Australian Painting: Colonial, Impressionist, Contemporary* in 1962. Recognizing the graphic potential of the Australian painters, Bernhard Baer, a German Jewish refugee print publisher who ran the Ganymed Press in London, commissioned Sidney Nolan in 1961 to make his first portfolio of eight lithographs, the *Leda Suite*.[6] In 1970 Ganymed Press published Arthur Boyd's *Lysistrata*, a suite of twenty etchings, similarly inspired by a classical theme, and in 1977 Brett Whiteley's suite of nude lithographs, *Towards Sculpture*. These major achievements by leading Australian artists were presented by Bernhard and Ann Baer to the British Museum in 1980 and 1985, the first significant additions of Australian prints since the initial flurry of enthusiasm in the 1920s. A further enhancement to the collection came in 1988, the bicentennial year of Australia's settlement by Europeans, when the Australian Government in association with the National Gallery of Australia presented the Bicentennial Folio, comprising twenty-five prints by twenty-five contemporary Australian artists, for some of whom printmaking was a new venture. A second bicentennial gift of contemporary prints was made by the Australian Legal Group; both portfolios were also presented to other major institutions overseas.

Over the past decade there has been a steady development of the collection as particular gaps were identified. The first examples of Fred Williams were purchased in 1996, followed by Jessie Traill, Australia's most important woman etcher between the wars, and Frank Hinder, a late protagonist of cubo-futurism working in Sydney. Monotypes, drawings and watercolours by the German Jewish artists Erwin Fabian and Klaus Friedeberger, who had been interned as 'enemy aliens' in England in 1940 and despatched on the prison ship *Dunera* to remote camps in Australia, have also been acquired either by purchase or gift. Other works on paper by G.W. Bot, Ian Friend, John Nixon and Ken Whisson have also been purchased.

But with a very limited budget for acquisitions, the collection has grown largely through the generosity of Australian artists, print workshops and fellow institutions. The artists Alun Leach-Jones and Danny McDonald have donated examples of their prints, while a group of works by Elizabeth Rooney was donated by her fellow artist and friend, Klaus Friedeberger. In 1996, through its director Anne Virgo, the Australian Print Workshop (formerly the Victorian Print Workshop) in Melbourne gave a carefully selected group of ten prints by ten leading artists, including the Aboriginal artists Judy Watson and Tommy May, representing different responses to diverse Australian landscapes of desert, tropical rainforest, beaches and coastal scrubland. The Melbourne printer John Loane, who set up the Viridian Press in 1987 after six years as director of the Victorian Print Workshop, has given large-scale intaglio prints by two artists with whom he has closely collaborated: Mike Parr, whose *Psychopathic Family*, 1995, consists of twelve expressionistic sugar aquatints, and the Romanian-born Aida Tomescu, whose *Ithaca*, 1997, a suite of ten drypoint etchings, is a poignant rumination on her homeland.

Institutions have been equally generous. Through the advice of its Senior Curator of Australian prints and drawings, Roger Butler, the National Gallery of Australia formally presented nineteen prints by Arthur Boyd at the British Museum in 2000. Comprising duplicates de-accessioned from the National Gallery's collection, the gift includes Boyd's series of lithographs inspired by the life of St Francis of Assisi and several individual etchings produced in London during the 1960s. Most recently, the Museum of Modern Art at Heide, Melbourne, together with the artist's family, has given a group of concrete-poem screenprints, all of them duplicates, made by Sweeney Reed in the 1970s.

A phenomenon of the past thirty years has been the development of Aboriginal printmaking. Apart from stencilled handprints found in caves, which are among the oldest replicated images in human history, there has been no tradition of printmaking among Aboriginal peoples. Yet, as Roger Butler has stated, in recent decades 'many Aboriginal artists have found printmaking a natural extension to their painting and sculpture'.[7] *Crossroads*, the first group portfolio of prints by Aboriginal artists, was produced at the close of the millennium in 1999, and contains twelve prints by twelve Aboriginal artists from both rural and urban communities who have achieved prominence within Australia and internationally. Among those included are Johnny Bulunbulun, Ginger Riley and Rover Thomas, whose etching gave the title to the portfolio and was the last work he produced before his death. The portfolio was presented to the Print Room by Gordon Darling and the publisher Leo Christie in 2002, to mark Neil MacGregor's appointment to the British Museum.

With the close curatorial links with Australia fostered by the Harold Wright scholarship and the generosity of Australian donors such as Lyn Williams, the aspiration of Lionel Lindsay to develop a collection of Australian prints at the British Museum is finally taking shape, although on a much broader basis than he had envisaged.

Above: fig.31 Henri Van Raalte (1881–1929),
The Gust, *c*.1917-19, drypoint,
424 x 327 mm (London, British Museum)

Top: fig.32 Hans Heysen (1877-1968),
Landscape, *c*.1911, etching,
195 x 148 mm (London, British Museum)
© DACS 2003

1 See Margaret Plant, 'Render Unto the Gum Tree', *The Real Thing*, exh. cat., Museum of Modern Art at Heide, Melbourne 1997, pp.55–62.
2 Lionel Lindsay, 'Etching in Australia', *Print Collector's Quarterly*, vol.11 no.3 (October 1924), pp.293–318.
3 Fred C. Britton, letter to Campbell Dodgson, 4 February 1924. Correspondence from Lionel Lindsay and the Australian artists who agreed to donate is kept in the Department of Prints and Drawings, Letters Received, vol.1924–9, letters from December 1923 to February 1924.
4 Lionel Lindsay, op. cit., p.304.
5 Philip James, 'Foreword', *Twelve Australian Artists*, exh.cat., intro. by Laurence Thomas, The Arts Council of Great Britain, n.d. [1953], p.5. The exhibition ran at the New Burlington Galleries, London from 12 July to 22 August 1953, and subsequently toured to Bath, Bradford, Derby, Bristol and Belfast into the following year.
6 See Bernhard Baer, 'Introduction', *Ganymed. Printing, Publishing, Design*, exh.cat., Victoria and Albert Museum, London, 19 November – 31 January 1981, pp.1–12.
7 Roger Butler's essay accompanies the print portfolio *Crossroads*, 1999, published by 21C Pty Ltd, Sydney.

Catalogue

The following catalogue of works by Fred Williams (1927–1982) in the Department of Prints and Drawings at the British Museum is divided into the etchings [Cats 1–79], lithograph [Cat. 80], and drawings, watercolours and gouaches [Cats 81–9]. The etchings are listed in the order of the catalogue raisonné compiled by James Mollison (see below), which catalogued all the etchings produced by Williams up to 1967 (Mollison 246). A yet unpublished continuation of the catalogue for the etchings has been subsequently compiled by Mollison, and this numbering has been followed for the post-1967 etchings listed here.

ABBREVIATIONS

Canberra 1987
Fred Williams: A Retrospective, exh. cat., Canberra, Australian National Gallery, 7 November 1987 – 31 January 1988

McCaughey
Patrick McCaughey, *Fred Williams 1927–1982*, 3rd rev. edn, Sydney 1996

Mollison
James Mollison, *Fred Williams Etchings*, introduction by John Brack, Woollahra (Sydney) 1968

Mollison 1989
James Mollison, *A Singular Vision: The Art of Fred Williams*, Canberra 1989

ETCHINGS

1 *Tumblers*, 1954–5 (p.44)
2nd state of 2; one of two proofs lettered A to B
Etching, on cartridge paper; signed and annotated *B* in pencil
106 x 100 mm, Mollison 2.II
2003-5-31-101. Presented by James Mollison

2 *Dancing Figures*, 1954–5 (p.46)
3rd state of 4
Etching, aquatint, engraving and drypoint, on Kent paper; signed and numbered *9-14* in pencil
195 x 200 mm, Mollison 6.III
2002-9-29-58. Presented by Lyn Williams

Related work: *Dancing Figures*, 1952–4, gouache and watercolour, National Gallery of Australia, Canberra (reprod. Canberra 1987, no.220)

3 *The Orchestra*, 1955–6 (p.47)
5th state of 5
Etching, aquatint and drypoint, on Kent paper; signed and numbered *9-10* in pencil
71 x 165 mm, Mollison 9.V
2002-9-29-59. Presented by Lyn Williams

4 *The Angel at Islington*, 1955–6 (p.57)
1st state of 4 before plate cut
Etching, aquatint, drypoint and open bite, on cartridge paper
175 x 96 mm, Mollison 12.I
2003-5-31-102. Presented by James Mollison
This proof is additional to the single example of the 1st state previously known to Mollison.

5 *The Angel at Islington*, 1955–6 (p.57)
3rd state of 4
Etching, aquatint, drypoint and open bite, on Kent paper; signed and numbered *6-7* in pencil
106 x 96 mm, Mollison 12.III
2002-9-29-60. Presented by Lyn Williams
Related work: *The Angel at Islington*, 1952-4, conté crayon and charcoal [Cat. 81]
This appears to be Collins' Music Hall at Islington Green before it was destroyed by fire in 1956.

6 *Finale*, 1955–6 (p.49)
2nd state of 3
Etching, engraving and drypoint, on Kent paper; signed and numbered *10-10* in pencil
147 x 198 mm, Mollison 16.II
2002-9-29-61. Presented by Lyn Williams

7 *Mad Pianist*, 1955–6 (p.48)
2nd state of 2
Etching and engraving, on Kent paper; signed and numbered *19-20* in pencil
117 x 167 mm, Mollison 17.II
2002-9-29-62. Presented by Lyn Williams

8 *Two Actors on Stage*, 1955–6 (p.54)
1st state of 3 before plate cut, one of four proofs lettered A to D
Etching, aquatint and drypoint, on

Whatmans paper; signed and annotated *C 1st state*
124 x 174 mm, Mollison 23.I
2003-5-31-103. Presented by James Mollison

9 *Two Actors on Stage*, 1955–6 (p.55)
3rd state of 3
Etching, aquatint and drypoint, on Kent paper; signed and numbered *5-5* in pencil
125 x 145 mm, Mollison 23.III
2002-9-29-63. Presented by Lyn Williams

10 *Two Actors on Stage*, 1955–6 (p.55)
Counterproof of final state; one of three proofs lettered A to C
Etching, aquatint and drypoint, on Kent paper; signed and annotated *A.* in pencil
125 x 144 mm, Mollison 23.III
2002-9-29-64. Presented by Lyn Williams

11 *Trampoline*, 1955–6 (p.45)
1st state of 5; one of seven proofs lettered A to G
Etching, aquatint and drypoint, on Whatmans paper; signed and annotated *D 1st state* in pencil
147 x 195 mm, Mollison 39.I
2002-9-29-65. Presented by Lyn Williams
Related work: *Trampoline*, c.1955–6, gouache and watercolour, private collection (reprod. Canberra 1987, no.247)

12 *Swinging*, 1955–6 (p.53)
1st state of 2
Etching, aquatint, engraving and rough biting, on Kent paper; signed and numbered *9-12* in pencil
153 x 99 mm, Mollison 41.I
2002-9-29-66. Presented by Lyn Williams

13 *The Can Can*, 1955–6 (p.51)
2nd state of 2
Etching, aquatint and engraving, on Kent paper; signed and numbered *1-10* in pencil
149 x 101 mm, Mollison 47.II
2002-9-29-67. Presented by Lyn Williams

14 *Dancer*, 1955–6 (p.52)
5th state of 6
Etching, aquatint and drypoint, on Kent paper; signed and numbered *2-5* in pencil
147 x 102 mm, Mollison 49.V
2002-9-29-68. Presented by Lyn Williams

15 *Acrobat*, 1955–6 (p.52)

1st state of 2
Etching and aquatint, on Kent paper; signed and numbered *1-10* in pencil
161x 121 mm, Mollison 50.I
2002-9-29-69. Presented by Lyn Williams

16 *Trapeze*, 1955–6 (p.53)
2nd state of 4
Etching, aquatint and drypoint, on Whatmans paper; signed and numbered *12-12* in pencil
200 x 163 mm, Mollison 51.II
2002-9-29-70. Presented by Lyn Williams

17 *'The Boy Friend'*, 1955–6 (p.50)
1st state of 2
Etching, aquatint, engraving and drypoint, on Whatmans paper; signed and numbered *5-16* in pencil
200 x 163 mm, Mollison 52.I
2002-9-29-71. Presented by Lyn Williams
This was inspired by Sandy Wilson's *The Boy Friend*, the highly successful musical comedy, which ran for more than 2,000 performances at Wyndhams Theatre, London, from January 1954.

18 *Hakea*, 1963 (p.62)
4th state of 5
Etching, aquatint and drypoint printed in sepia, on Kent paper; signed and numbered *6-45* in pencil
135 x 90 mm, Mollison 135.IV
1996-6-8-15. Presented by Irena Zdanowicz

19 *Tumblers Number 2*, 1967 (p.58)
1st state of 5
Deep etching, on blue Ingres paper; signed and numbered *8-20* in pencil
254 x 193 mm, Mollison 163.I
2002-9-29-72. Presented by Lyn Williams
Related works: *Tumblers*, c.1953–4, conté crayon [Cat. 82]; *Tumblers*, 1967, oil on canvas, private collection (reprod. McCaughey, p.209, pl.113)

20 *Tumblers Number 2*, 1967 (p.59)
5th state of 5
Etching, deep etching, and flat biting with rocker, on grey Ingres paper; signed and numbered *30-30* in pencil
253 x 173 mm, Mollison 163.V
2002-9-29-73. Presented by Lyn Williams

21 *Gum Tree*, 1958 (p.62)
3rd state of 4

Aquatint, engraving, rough biting and drypoint, on Kent paper; signed and numbered *3-10* in pencil
149 x 99 mm, Mollison 168.III
2002-9-29-74. Presented by Lyn Williams

22 *Red Trees*, 1958 (p.71)
2nd state of 3
Etching, aquatint and drypoint printed in sepia, on Kent paper; signed and numbered *1-14* and annotated *2* [state] in pencil
201x 147 mm, Mollison 171.II
1996-6-8-5

23 *Burning Log*, 1958-9 (p.67)
2nd state of 3
Aquatint, engraving, etching and drypoint, on Kent paper; signed and numbered *13-20* in pencil
212 x 129 mm, Mollison 172.II
2002-9-29-75. Presented by Lyn Williams
Related work: *Burning Log*, 1957, gouache, National Gallery of Australia, Canberra (reprod. Mollison 1989, p.34)

24 *Landscape with a Steep Road*, 1959 (p.64)
3rd state of 5
Aquatint, etching, drypoint and engraving, on Kent paper; signed and numbered *5-8* in pencil
196 x 157 mm, Mollison 174.III
2002-9-29-76. Presented by Lyn Williams
Related work: *Landscape with a Steep Road*, 1957 (fig.12, p.18), oil on composition board, National Gallery of Australia, Canberra

25 *The St George River, Lorne*, 1959–60 (p.65)
4th state of 4 (completed in 1966)
Etching, aquatint, engraving and drypoint, on Arches paper; signed and numbered *3-30* in pencil
162 x 277 mm, Mollison 176.IV
2002-9-29-77. Presented by Lyn Williams
Related work: *The St George River*, 1960 (fig.14 p.21), oil on canvas on composition board, Tate, London

26 *Sandstone Hill Number 1*, 1961 (p.63)
1st state of 2
Aquatint, engraving and drypoint, on Kent paper; signed and numbered *12-20* in pencil
105 x 212 mm, Mollison 182.I

2002-9-29-78. Presented by Lyn Williams

27 *Sapling Forest*, 1961 (p.70)
2nd state of 4
Aquatint, engraving and drypoint, on Kent paper; signed and numbered *8-25* in pencil
132 x 201 mm, Mollison 184.II
2002-9-29-79. Presented by Lyn Williams
Related works: *Sapling Forest*, c.1961, oil and tempera on composition board, National Gallery of Victoria, Melbourne (reprod. McCaughey, p.149, pl. 60); *Sapling Forest*, 1962, oil and tempera on composition board, private collection, London (reprod. McCaughey, p.150, pl.62)

28 *Echuca Landscape*, 1961 (p.72)
3rd state of 16; only proof
Engraving, on Kent paper; signed and annotated *A 3rd state* in pencil
157 x 191 mm, Mollison 185.III
2002-9-29-80. Presented by Lyn Williams
Related works: *Echuca Landscape*, 1961, oil on composition board, Queensland Art Gallery, Brisbane (repr. Canberra 1987, no.38); *Echuca Landscape*, 1962, oil and tempera on composition board, private collection (reprod. Mollison 1989, p.68)

29 *Echuca Landscape*, 1961 (p.73)
7th state of 16
Engraving and aquatint, on Kent paper; signed and numbered *3-8* in pencil
153 x 193 mm, Mollison 185.VII
2002-9-29-81. Presented by Lyn Williams

30 *Echuca Landscape*, 1963 (p.73)
13th state of 16
Engraving, aquatint and drypoint, on Kent paper; signed and numbered *13-26* in pencil
154 x 193 mm, Mollison 185.XIII
2002-9-29-82. Presented by Lyn Williams
Shows a lighter band of polished aquatint in the centre

31 *Echuca Landscape*, 1963 (p.74)
15th state of 16
Engraving, aquatint and drypoint, printed in sepia on Kent paper; signed and numbered *10-30/2* in pencil
157 x 190 mm, Mollison 185.XV
2002-9-29-83. Presented by Lyn Williams
Shows rich burr from re-engraved line at top centre and coarse-grained aquatint added at lower right

32 *Echuca Landscape*, 1963 (p.75)
16th state of 16
Engraving and drypoint, on Kent paper; signed and numbered *23-65* in pencil
154 x 194 mm, Mollison 185.XVI
2002-9-29-84. Presented by Lyn Williams
Related work: *Echuca Landscape II*, 1966 (fig.16, p.22), oil on canvas, Estate of Fred Williams
In the final state the aquatint was polished out, leaving only residual traces.

33 *Saplings*, 1962 (p.67)
4th state of 9
Aquatint, drypoint and engraving, on Kent paper; signed and annotated *5-5 IV* in pencil
246 x 148 mm, Mollison 191.IV
2002-9-29-85. Presented by Lyn Williams
Related works: *Saplings, Mittagong*, 1958, gouache and watercolour, National Gallery of Australia, Canberra (reprod. Mollison 1989, p.39); *Saplings, Mittagong*, 1962, watercolour [Cat. 83]

34 *Landscape Triptych Number 1*, 1962 (p.69)
Three plates printed side by side on one sheet
2nd state of 4
Sugar aquatint, engraving and drypoint, printed in sepia on Kent paper; signed and numbered *9-35* in pencil
122 x 271 mm (overall), Mollison 200.II
2002-9-29-86. Presented by Lyn Williams
Related works: *Triptych Landscape*, 1962, oil and tempera on three composition boards, News Corporation Collection (reprod. Mollison 1989, pp.72–3); *Triptych*, 1962, watercolour on three sheets of paper, private collection (reprod. Canberra 1987, no.259)

35 *Landscape Triptych Number 2*, 1962 (p.69)
Three plates printed side by side on one sheet
4th state of 5; 1 of 7 proofs
Aquatint, engraving and drypoint, printed in sepia on Kent paper; signed and annotated *B 4th state* in pencil
127 x 282 mm (overall), Mollison 201.IV
2002-9-29-87. Presented by Lyn Williams

36 *You Yangs Landscape Number 1*, 1963 (p.80)
4th state of 5

Aquatint, engraving and drypoint, printed in sepia on Kent paper; signed and numbered *10-45* in pencil
272 x 303 mm, Mollison 206.IV
2002-9-29-88. Presented by Lyn Williams
Related works: *You Yangs Landscape I*, 1963, oil and tempera on composition board, private collection (reprod. Mollison 1989, p.78); for a related drawing, see *You Yangs Series* [Cat. 86]

37 *You Yangs Landscape Number 1*, 1964 (p.81)
5th state of 5 after plate cut
Aquatint, engraving and drypoint, on Kent paper; signed and numbered *22-30* in pencil
278 x 181 mm, Mollison 206.V
2002-9-29-89. Presented by Lyn Williams
The plate was cut down and a heavy horizontal drypoint line added across the top.

38 *You Yangs Pond*, 1963 (p.82)
4th state of 8
Etching, aquatint, engraving and drypoint, printed in sepia on Kent paper; signed and numbered *15-20* in pencil
235 x 301 mm, Mollison 207.IV
2002-9-29-90. Presented by Lyn Williams
Related works: *You Yangs Pond*, 1963, oil and tempera on composition board, Art Gallery of South Australia, Adelaide (reprod. McCaughey, p.160, pl.71); *You Yangs Pond*, 1967, gouache, National Gallery of Victoria, Melbourne (reprod. Canberra 1987, no.279)

39 *You Yangs Pond*, 1964 (p.83)
8th state of 8 after plate cut, removing pond
Etching, aquatint, engraving and drypoint, on Saunders paper; signed and numbered *4-30* in pencil
161 x 300 mm, Mollison 207.VIII
2002-9-29-91. Presented by Lyn Williams

40 *Knoll in the You Yangs*, 1963 (p.84)
16th state of 17
Aquatint, engraving and drypoint, on Kent paper; signed and numbered *25-25* in pencil
295 x 456 mm, Mollison 208.XVI
2002-9-29-92. Presented by Lyn Williams
Related works: *Knoll in the You Yangs I*, 1963, watercolour and gouache, National Gallery of Australia, Canberra (reprod.

Mollison 1989, p. 83); *Knoll in the You Yangs II*, *c.*1963, chalk and charcoal, private collection (reprod. Canberra 1987, no. 267); *Knoll in the You Yangs*, 1965 (fig.18, p.27), oil on canvas, collection of Lyn Williams
There were originally 35 states of this print, although Mollison noted that 'only the most attractive proofs from among these remain'. In 1964, the plate was cut in two [Cats 41 and 42].

41 *Knoll in the You Yangs*, 1964 (p.85)
17th state (A) of 18 after plate cut in two, with this being the former left half of the plate
Aquatint, engraving and drypoint, on Saunders paper; signed and numbered *29-30* in pencil
246 x 298 mm, Mollison 208.XVIIA
2002-9-29-93. Presented by Lyn Williams

42 *Knoll in the You Yangs*, 1964 (p.85)
17th state (B) of 18 after plate cut in two, with this being a piece from the former right half of the plate
Aquatint, engraving and drypoint, on Kent paper; signed and numbered *25-25* in pencil
191 x 132 mm, Mollison 208.XVIIB
2002-9-29-94. Presented by Lyn Williams

43 *You Yangs Landscape Number 2*, 1966 (p.86)
5th state of 5
Etching, engraving and drypoint, on cream Ingres paper; signed and numbered *3-14* in pencil
266 x 203 mm, Mollison 209.V
2002-9-29-95. Presented by Lyn Williams
Begun in 1963. Williams returned to the plate in 1966 to create the 4th and 5th states.

44 *First Variation of You Yangs Landscape Number 1*, 1965-6 (p.86)
3rd state of 3
Etching, engraving and drypoint, on Arches paper; signed and numbered *5-21* in pencil
265 x 162 mm, Mollison 210.III
2002-9-29-96. Presented by Lyn Williams

45 *Decorative Panel, You Yangs Number 3*, 1965-6 (p.88)
1st state of 2
Etching, engraving and flat biting, on

Saunders paper; signed and numbered *11-30* in pencil
200 x 105 mm, Mollison 214.I
2002-9-29-97. Presented by Lyn Williams
Related work: *Decorative Panel, You Yangs*, 1966, oil on canvas (reprod. Canberra 1987, no.69)

46 *Decorative Panel, You Yangs Number 3*, 1965-6 (p.88)
2nd state of 2
Etching, engraving, flat biting and mezzotint rocker, on Arches paper; signed and numbered *1-25* in pencil
201 x 105 mm, Mollison 214.II
2003-5-31-104. Presented by James Mollison
In the 2nd state lines were added with the mezzotint rocker.

47 *Circle Landscape, Upwey*, 1965-6 (p.90)
4th state of 5
Etching, aquatint and drypoint, on Arches paper; signed and numbered *30-40* in pencil
284 mm (diam.), Mollison 221.IV
1996-6-8-13. Presented by Lyn Williams
Related work: *Circle Landscape*, 1965-6, oil on canvas, private collection (reprod. Mollison 1989, p.95)

48 *Gum Trees in Landscape, Lysterfield*, 1965-6 (p.92)
3rd state of 4
Etching, aquatint, sugar aquatint and drypoint, on Saunders paper; signed and numbered *6-20* in pencil
270 x 181 mm, Mollison 223.III
2002-9-29-98. Presented by Lyn Williams
Related work: *Gum Trees in Landscape I*, 1965-6, oil on canvas, private collection (reprod. Mollison 1989, p.100)

49 *Hillside Number 1*, 1965-6 (p.91)
2nd state of 3
Etching, aquatint and drypoint, on Kent paper; signed and numbered *9-25* in pencil
198 x 213 mm, Mollison 224.II
1996-6-8-6
Related work: *Hillside I*, 1971, acrylic, private collection (reprod. McCaughey, p.154, pl.65)

50 *Landscape with Green Cloud and Owl*, 1965-6 (p.89)

1st state of 2
Etching and aquatint, on Saunders paper; signed and numbered *5-30* in pencil
248 x 267 mm, Mollison 232.I
2002-9-29-99. Presented by Lyn Williams
Related works: *Green Cloud and Owl*, 1965, gouache, National Gallery of Australia, Canberra (reprod. Mollison 1989, p.92); *Green Cloud and Owl*, 1965-6, oil on canvas, private collection (reprod. Mollison 1989, p.93)
This is before the owl and cloud appear in the final state.

51 *Forest of Gum Trees*, 1965-6 (p.95)
4th state of 4
Etching and flat biting with rocker, on cream Ingres paper; signed and numbered *4-5* in pencil
342 x 274 mm, Mollison 237.IV
2002-9-29-100. Presented by Lyn Williams
Related work: *Forest of Gum Trees III*, 1968-70 (fig.20, p.28), oil on canvas, Estate of Fred Williams

52 *Hillside at Lysterfield*, 1965-6 (p.94)
5th state of 5
Etching, engraving, drypoint and flat biting, on Arches paper; signed and numbered *7-10* in pencil
288 x 353 mm, Mollison 239.V
2002-9-29-101. Presented by Lyn Williams
Related work: *Hillside at Lysterfield II*, 1967, oil on canvas, private collection (reprod. Mollison 1989, p.105)

53 *Oval Landscape*, 1965-6 (p.90)
4th state of 5
Sugar aquatint, engraving and drypoint, on Arches paper; signed, dated *65*, and annotated *3rd state/1/7* in pencil
298 x 184 mm, Mollison 242.IV
2002-9-29-102. Presented by Lyn Williams
Related work: *Oval Landscape*, 1965-6, oil on canvas, private collection (reprod. Mollison 1989, p.98)
This impression was exhibited at Cracow's First International Print Biennale in 1966, priced at *$50 Australian*.

54 *Chopped Trees, Lysterfield*, 1966-7 (p.93)
Only state
Etching, aquatint, drypoint and flat biting, on Arches paper; signed and numbered *4-25* in pencil
248 x 392 mm, Mollison 245

2002-9-29-103. Presented by Lyn Williams
Related work: *Chopped Trees III*, 1967, oil on canvas, private collection (reprod. Mollison 1989, p.99)

55 *Canberra Triptych (Lysterfield)*, 1970 (p.97)
Three plates printed side by side on one sheet
2nd state of 2
Etching and drypoint, printed in dark brown on Saunders paper; signed and numbered *27-30* in pencil
202 x 540 mm (overall), Mollison 250.II
2002-9-29-104. Presented by Lyn Williams
Related work: *Lysterfield Triptych*, 1967-8, oil on three canvases, National Gallery of Australia, Canberra (reprod. Mollison 1989, pp.112–13)
The reference to Canberra in the print title is to the painting held by the National Gallery of Australia.

56 *Ferns Diptych Number 2*, 1970 (p.110)
Two plates printed side by side on one sheet
2nd state of 3
Etching, aquatint and drypoint, on Arches paper; signed and numbered *4/30* in pencil
276 x 463 mm (overall), Mollison 256A.II
2002-9-29-105. Presented by Lyn Williams
Related works: *Ferns I*, 1968-70, oil on canvas, private collection, and *Ferns II*, 1968-70, oil on canvas, private collection, which correspond, respectively, to the right and left plates (reprod. Mollison 1989, pp. 130 and 131, respectively)

57 *Silver and Grey Landscape*, 1971 (p.101)
3rd state of 3
Drypoint with electric hand engraving tool and roulette, on Aquarelle Arches paper; signed and numbered *6-25* in pencil
202 x 255 mm, Mollison 257.III
2002-9-29-106. Presented by Lyn Williams
Related work: *Silver and Grey V*, 1969, oil on canvas, Estate of Fred Williams (reprod. Canberra 1987, no.116)

58 *Lysterfield Number 1*, 1972 (p.102)
4th state of 4
Etching and engraving with electric hand engraving tool and roulette, printed in dark brown on Saunders paper; signed and numbered *13-16* in pencil

453 x 350 mm, Mollison 259.IV
2002-9-29-107. Presented by Lyn Williams
Related work: *Lysterfield*, 1968-70, oil on canvas, private collection (reprod. Mollison 1989, p.109)

59 *Lysterfield Number 2*, 1972 (p.102)
1st state of 2
Etching and engraving with electric hand engraving tool and roulette, printed in red ochre on Dessin-ja-Arches France paper; signed, dated and annotated *2/6 1st state* in pencil
449 x 355 mm, Mollison 260.I
2002-9-29-108. Presented by Lyn Williams

60 *Panel 1, Murray River, Number 1*, 1972 (p.103)
2nd state of 2
Etching with roulette and foul biting, printed with light plate tone, on Dessin-ja-Arches France paper; signed, dated *72* and numbered *2/20* in pencil
138 x 548 mm, Mollison 262.II
2002-9-29-109. Presented by Lyn Williams
Related works: This suite of eight etchings [Cats 60–68] is after the eight panels forming the Adelaide Festival Theatre Murals, 1972-3, oil on canvas on composition board, commissioned by the Adelaide Theatre Trust in 1972 (reprod. McCaughey, pp.242–3, pl.141 and pp.246–7, pl.142). Although the prints are mostly dated 1972 (the year in which Williams received the commission for the murals), according to the *Diary* they were begun in March 1973 and the printing was finished in November 1974.

61 *Panel 2, Murray River, Number 2*, 1972 (p.104)
2nd state of 2
Etching with roulette and foul biting, on Dessin-ja-Arches France paper; signed, dated *72* and numbered *4/15* in pencil
120 x 548 mm, Mollison 263.II
2002-9-29-110. Presented by Lyn Williams

62 *Panel 3, Murray River, Number 3*, 1972–3 (p.104)
1st state of 2
Etching and engraving with roulette and foul biting, on J. Perrigot Arches Spécial MBM paper; signed, dated *72* and numbered *6/15* in pencil
138 x 556 mm, Mollison 264.I
2002-9-29-111. Presented by Lyn Williams

63 *Panel 4, Murray River, Number 4*, 1972-3 (p.105)
3rd state of 4
Etching, drypoint and engraving with mezzotint rocker, electric hand engraving tool and roulette, printed in sanguine on Arches 88 France paper; signed, dated 72 and numbered *6/15* in pencil
119 x 555 mm, Mollison 265.III
2002-9-29-112. Presented by Lyn Williams

64 *Panel 4, Murray River, Number 4*, 1972-3 (p.105)
4th state of 4
Etching, drypoint and engraving with mezzotint rocker, electric hand engraving tool and roulette, on white wove paper; signed, dated *73* and annotated *10/18 2nd state* [*sic*] in pencil
119 x 555 mm, Mollison 265.IV
2002-9-29-113. Presented by Lyn Williams

65 *Panel 5, Murray River, Number 5*, 1972 (p.106)
2nd state of 2
Etching and engraving with foul biting and roulette, printed in sanguine on Arches 88 France paper; signed, dated *72* and numbered *15/18* in pencil
138 x 555 mm, Mollison 266.II
2002-9-29-114. Presented by Lyn Williams

66 *Panel 6, Glass House Mountains*, 1972 (p.106)
2nd state of 2
Etching, aquatint, drypoint and engraving with foul biting and roulette, printed in sanguine with light plate tone on Dessin-ja-Arches France paper; signed and annotated *Proof 3/3* in pencil (edition 16)
139 x 550 mm, Mollison 267.II
2002-9-29-115. Presented by Lyn Williams

67 *Panel 7, Cannons Creek*, 1972 (p.107)
2nd state of 2
Etching and engraving with foul biting and roulette, printed with plate tone, on J. Perrigot Arches Spécial MBM paper; signed, dated *72* and numbered *6/15* in pencil
119 x 556 mm, Mollison 268.II
2002-9-29-116. Presented by Lyn Williams

68 *Panel 8, Murray River Number 6*, 1972 (p.107)
Only state
Etching with foul biting and roulette, printed with plate tone on Arches 88 France paper; signed, dated *72* and numbered *19/20*
119 x 555 mm, Mollison 269
2002-9-29-117. Presented by Lyn Williams

69 *Landscape with Goose*, 1973 (p.111)
3rd state of 3
Drypoint and engraving with electric hand engraving tool and roulette, on Lavis Montgolfier St Marcel Les Annonay paper; signed and numbered *6/20* in pencil
255 x 198 mm, Mollison 272.III
2002-9-29-118. Presented by Lyn Williams
Related work: *Landscape with a Goose*, 1974, oil on canvas, National Gallery of Australia, Canberra (reprod. Mollison 1989, p. 182)

70 *Plenty Gorge*, 1973 (p.100)
4th state of 4
Drypoint and engraving with electric hand engraving tool, roulette and scraping, on Lavis Montgolfier St Marcel Les Annonay paper; signed and numbered *12/22* in pencil
221x 285 mm, Mollison 273.IV
2002-9-29-119. Presented by Lyn Williams

71 *Yellow Landscape '74*, 1974 (p.112)
Only state
Drypoint and engraving with electric hand engraving tool, on Saunders paper; signed and numbered *10/22* in pencil
253 x 449 mm, Mollison 276
2002-9-29-120. Presented by Lyn Williams
Related work: *Landscape '74*, 1974–5, oil on canvas, National Gallery of Australia, Canberra (reprod. Mollison 1989, pp.180–81)

72 *Forest Pond '74*, 1974 (p.113)
2nd state of 2
Aquatint, etching, drypoint and engraving with electric hand engraving tool, on Lavis Montgolfier St Marcel Les Annonay paper; signed and annotated *3/8 1st state* in pencil
254 x 447 mm, Mollison 277.II
2002-9-29-121. Presented by Lyn Williams

73 *Kate Watching TV*, 1974 (p.59)
4th state of 5
Aquatint, drypoint, and engraving with electric hand engraving tool and roulette, on Saunders paper; signed and annotated *4th state 3/8* in pencil
256 x 201 mm, Mollison 282.IV

2002-9-29-122. Presented by Lyn Williams

74 *Yarra Billabong, Kew Number 1*, 1975 (p.116)
Only state
Aquatint, drypoint and engraving with electric hand engraving tool and roulette, on Saunders paper; signed and numbered *4/22* in pencil
230 x 278 mm, Mollison 283
2002-9-29-123. Presented by Lyn Williams
Related work: *Kew Billabong I*, 1975, oil on canvas, private collection (reprod. McCaughey, p.285, pl.178, as 'Kew Billabong II')

75 *Yarra Billabong, Kew Number 2*, 1975 (p.117)
Only state
Aquatint, drypoint, engraving with electric hand engraving tool, on Aquarelle Arches paper; signed and numbered *7/25* in pencil
290 x 292 mm, Mollison 284
2002-9-29-124. Presented by Lyn Williams
Related work: *Kew Billabong with Old Tyre I*, 1975 (fig.24, p.34), oil on canvas, Estate of Fred Williams

76 *Landscape Symbols, Cottlesbridge*, 1975 (p.118)
2nd state of 2
Drypoint and engraving with electric hand engraving tool and roulette, on Aquarelle Arches paper; signed and numbered *6/22* in pencil
248 x 247 mm, Mollison 289.II
2002-9-29-125. Presented by Lyn Williams

77 *Cottlesbridge, Landscape with Derelict Car*, 1975 (p.119)
Only state
Drypoint and engraving, with electric hand engraving tool and roulette, on Aquarelle Arches paper; signed and numbered *12/24* in pencil
251 x 251mm, Mollison 290
1996-6-8-14. Presented by Lyn Williams

78 *Road and Saplings, Cottlesbridge*, 1975 (p.115)
Only state
Aquatint, drypoint and engraving with electric hand engraving tool and roulette, on Aquarelle Arches paper; signed and numbered *2/20* in pencil
300 x 227 mm, Mollison 291
2002-9-29-126. Presented by Lyn Williams

79 *Forest Pond Triptych*, 1975 (p.114)
Three plates printed side by side on
one sheet
2nd state of 2
Drypoint and engraving with electric hand
engraving tool and roulette, on Aquarelle
Arches paper; signed and numbered *13/26*
in pencil
215 x 520 mm (overall), Mollison 293.II
2002-9-29-127. Presented by Lyn Williams
Related work: *Forest Pond Triptych*, 1974,
oil on three canvases, Sydney Opera
House Trust (reprod. McCaughey,
pp.266–7, pl.161)

LITHOGRAPH

80 *You Yangs Landscape*, 1964 (p.87)
Lithograph, printed in brown and black on
Kent paper; signed, dated *64* and
numbered *16-30* in pencil
310 x 242 mm (image); 456 x 368mm
(sheet)
2003-3-31-1. Presented by Lyn Williams

DRAWINGS, WATERCOLOURS AND
GOUACHES

81 *The Angel at Islington*, *c*.1952–4 (p.56)
Conté crayon and charcoal on paper
241 x 209 mm (sheet)
2003-3-30-1. Presented by Lyn Williams
For the related etching, see *The Angel at
Islington* [Cat. 5]

82 *Tumblers*, *c*.1953–4 (p.58)
Conté crayon on paper
265 x 209 mm (sheet)
2003-3-30-2. Presented by Lyn Williams
Later used as the basis for the 1967
etching *Tumblers Number 2* [Cat.19]

83 *Saplings, Mittagong*, 1962 (p.66)
Watercolour on paper
385 x 420 mm
Signed in ink. Verso: FW Estate no.
GW562
2003-3-30-3. Presented by Lyn Williams
For a related etching, see *Saplings* [Cat. 33]

84 *You Yangs Landscape*, 1962 (p.78)
Gouache, watercolour and chalk on paper
prepared with pink wash
342 x 470 mm
Signed and dated *Fred Williams. 64* in

brown gouache. (According to Lyn
Williams, this was wrongly dated by
the artist.)
2003-3-30-4. Presented by Lyn Williams

85 *Forest Diptych*, 1962 (p.68)
Watercolour on two sheets of paper
365 x 731 mm (overall)
Signed *Fred Williams.* in black chalk on left
sheet. Verso: FW Estate no. GW698 (left
sheet), 699 (right sheet)
2003-3-30-5 (1-2). Presented by Lyn
Williams
For related etchings, see *Landscape
Triptych Number 1* [Cat. 34] and
Landscape Triptych Number 2 [Cat.35];
Triptych, 1962, watercolour on three
sheets of paper, private collection (reprod.
Mollison 1989, p.71)

86 *You Yangs Series*, 1963 (p.79)
Black, sienna, ochre and white conté on
Kent paper
760 x 560 mm (sheet)
Verso: annotated by Lyn Williams *YOU
YANGS SERIES/ 1963*. FW Estate
no.D353
2003-3-30-6. Presented by Lyn Williams
For a related etching, see *You Yangs
Landscape Number 1* [Cat. 36]

87 *Australian Landscape No. 10*, 1969
(p.96)
Gouache on Arches paper
283 x 719 mm (image), 573 x 772 mm
(sheet)
Signed *Fred Williams.* in brown gouache.
Verso: FW Estate no. GW592
2003-3-30-7. Presented by Lyn Williams

88 *Bega No. 1*, 1975 (p.109)
Gouache in four strips on Arches paper,
564 x 775 mm
Signed *Fred Williams.* in grey gouache.
Verso: FW Estate no. GW754
2003-3-30-8. Presented by Lyn Williams

89 *Bega No. 3*, 1975 (p.108)
Gouache in four strips on Arches paper,
564 x 775 mm
Signed *Fred Williams.* in brown gouache.
Verso: FW Estate no. GW756
2003-3-30-9. Presented by Lyn Williams

Glossary

The print techniques described below are the main ones used by Fred Williams, who usually combined different methods on a single plate. For fuller explanations, see Antony Griffiths, *Prints and Printmaking: An introduction to the history and techniques*, British Museum Press, London 1996. A detailed analysis of the techniques used by Williams is given in James Mollison, *Fred Williams Etchings*, Woollahra (Sydney) 1968.

Aquatint

A variety of etching used to create tone, originally to imitate the effect of watercolour. A thin layer of resin particles is deposited on to a metal plate, which is then heated until the resin melts and fuses to the surface, creating a porous ground. The acid bites in the channels around each particle. These hold sufficient ink to print as an even tone. Highlights can be obtained by 'stopping out' with an acid-resistant varnish (see under *Etching*). Highlights can also be achieved by filing smooth small areas of the plate with a tool called a burnisher. These areas will then hold less ink, creating lighter parts of the composition. A scraper is used to lower the surface of the plate by removing pieces of the metal.

Counterproof

An offset made by passing a still-wet print through the press against another dampened sheet of paper. The result is an image in reverse to the print but in the same direction as the plate.

Drypoint

The line is drawn directly into a metal plate with a sharp point held like a pencil, which throws up a metal burr along the incision. Ink is retained in the burr, producing a rich feathery line when printed. Because the burr wears down easily under pressure from the press, only a limited number of impressions showing the full richness of the drypoint line can be achieved.

Engraving

Lines are cut cleanly and directly into the bare metal plate using a V-shaped tool called a burin.

Etching

A needle is used to draw freely through a hard, waxy acid-resistant ground covering the metal plate. The exposed metal is then 'bitten' by acid, creating the lines. This is done by immersing the plate in an acid bath; the longer the acid bites, the deeper the lines. The plate can be bitten to different depths by 'stopping out' the lighter lines with a varnish before returning the plate to the bath. The ground is then cleaned off before printing. *Flat biting* is achieved when the metal plate is slipped for a moment in the acid bath, resulting in a very lightly bitten plate which, when printed, produces a faint overall tone. *Rough biting*, also known as *open bite*, is achieved by applying the acid directly to parts of the plate with a feather, producing an uneven tone when printed. *Foul biting* usually occurs when acid penetrates an imperfectly covered ground, resulting in spots. Williams sometimes deliberately brought about this effect on his plates.

Intaglio printmaking

The traditional hand-drawn techniques of *etching*, *aquatint*, *drypoint* and *engraving* are all intaglio processes. The methods of printing are the same, but the result of each technique is different. The basic principle is that the line is incised into the metal plate, which is usually copper or zinc. Ink is rubbed into the recessed lines with a roller and the surface of the plate wiped clean. Printing is achieved by placing a sheet of dampened paper over the inked plate, which is then passed through the press under heavy pressure. Characteristic of intaglio printmaking is the plate mark impressed into the paper.

Mezzotint rocker

The plate is worked back and forth with a curved and toothed rocker. Williams uses the rocker to produce a series of near parallel, finely dotted lines.

Proof

An impression outside the edition, usually pulled during the process of working on the plate.

Roulette

Wheeled tools are used directly on to the metal plate, producing fine track-like dots.

States

While the artist works on the plate, proofs are taken which record the different stages, or states, in the development of the print. Each successive change on the plate is sequentially numbered. Williams's prints were sometimes achieved through a large number of states, such as *Echuca Landscape* [Cat. 28], which went through as many as sixteen states. From the early 1960s Williams began to pull small editions at each completed stage of the print

Select Bibliography

BOOKS AND CATALOGUES

Arts Council of Australia, *John Brack/Fred Williams*, Albert Hall, Canberra 1967 (exh. cat. with intro. by Ursula Hoff)

Australian National Gallery, *Fred Williams: A Retrospective*, Canberra 1987 (exh. cat.)

Australian National University, *Fred Williams: Painter/Etcher*, Canberra 1981 (exh. cat. with intro. by James Mollison)

Brack, J., *Four Contemporary Australian Landscape Painters* (National Gallery Booklet), Melbourne 1968

Brown, S., *Fred Williams: The Queensland Gouaches*, Gold Coast City Art Gallery, Surfer's Paradise (Queensland) 1996 (exh. cat.)

Catalano, G., *An Intimate Australia: The Landscape & Recent Australian Art*, Sydney 1985

Fuller, P., *Images of God: The Consolation of Lost Illusions*, London 1990

Fuller, P., *The Australian Scapegoat – Towards an Antipodean Aesthetic*, Nedlands (Western Australia) 1986

Gott, T., *Backlash: The Australian Drawing Revival 1976-1986*, National Gallery of Victoria, Melbourne 1986 (exh. cat.)

Gott, T., *Fred Williams: Drawing the Exotic*, Museum of Modern Art at Heide, Melbourne 1999 (exh. cat.)

Gott, T., *Fred Williams: Drawing the Nude*, Museum of Modern Art at Heide, Melbourne 2001 (exh. cat.)

Grant, K., 'Images of the Music Hall: Fred Williams in London, 1952–56', in *Brought to Light - Australian Art 1850–1960*, eds. Seear, L. & Ewington, J., Queensland Art Gallery, South Brisbane 1998, pp.240–43

Grishin, S., *Contemporary Australian Printmaking: An Interpretative History*, Roseville East (New South Wales) 1994

James, R., *Fred Williams: Coastal Strip*, Mornington Peninsula Regional Gallery,

Mornington (Victoria) 2001 (exh. cat.)

Leahy, C., 'Printmaking in Melbourne in the 1950s: An Institutional Study', unpublished M.A. Research Essay, Monash University, Clayton (Melbourne) 1997

Lindsay, R. & Zdanowicz, I., *Fred Williams: Works in the National Gallery of Victoria*, Melbourne 1980

Lyre Bird Press, *Fred Williams: Music Hall Etchings 1954–1956*, Townsville 1998 (with preface by Diana Davis and intro. by Barry Humphries)

McCaughey, P., *Fred Williams 1927–1982*, 3rd rev. edn, Sydney 1996

McCaughey, P., *Fred Williams – The Pilbara Series 1979–1981*, Melbourne 1983 (exh. cat.)

McDonald, J., (intro) *Fred Williams (1927–1982)*, Malborough Fine Art (London) Ltd, London 1995

McGregor, C., et al, *In the Making [by] Craig McGregor and Others*, Melbourne 1969

Mollison, J., *Fred William Etchings*, intro. by John Brack, Woollahra (Sydney) 1968 (cat. raisonné of the etchings to 1967)

Mollison, J., *A Singular Vision: The Art of Fred Williams*, Australian National Gallery, Canberra 1989

Mollison, J., *Fred Williams: A Working Method*, National Gallery of Victoria 1995 (exh. brochure)

Monash Gallery of Art, *The Enduring Landscape: Gouaches by Fred Williams from the Collection of the National Gallery of Victoria*, Wheelers Hill (Melbourne) 2000 (exh. brochure by Kirsty Grant)

Museum of Modern Art, *Fred Williams: Landscapes of a Continent*, New York 1977 (exh. brochure by William S. Lieberman)

Phipps, J. and Grant, K., *Fred Williams: The Pilbara Series*, National Gallery of Victoria, Melbourne 2002

Plant, M., 'Render unto the Gum Tree', in Engberg, J. (ed.), *The Real Thing*, Museum of Modern Art at Heide, Melbourne 1997 (exh. cat.)

Roberts, J., *Fred Williams Landscapes 1959-1981*, Monash University Faculty of Art and Design, Caulfield East [2001] (exh. brochure)

Ryan, A., & Kolenberg, H., *Fred Williams: From Music Hall to Landscape, Drawings and Prints*, Art Gallery of New South Wales, Sydney 2001 (exh. cat.)

Tasmanian Museum and Art Gallery, *Fred Williams: Bass Strait Landscapes 1971–1978*, Hobart 1981 (exh. cat. with intro. by Hendrik Kolenberg)

University Gallery, University of Melbourne, *Fred Williams Recent Paintings: a Current Working Exhibition*, Parkville 1975 (exh. cat. with notes by James Mollison)

Victoria & Albert Museum, *Australian Prints*, London 1972 (exh. cat. with intro. by James Mollison and Margaret MacKean)

Zimmer, J. (ed), *The Crossley Gallery 1966–1980*, Melbourne 2003

ARTICLES

Burke, J., and Davies, S., 'Tate Adams and Melbourne Printmaking', *Imprint*, no.2, 1979, not paginated

Cross, E., 'Fred Williams', *Imprint*, no.4, 1975, pp.2–5.

Davie, A., 'Fred Williams: A Major Exhibition', *Art Monthly Australia*, no.5, Oct. 1987, pp.4–8 (interview with Lyn Williams and James Mollison)

Holloway, M., 'Colonizing the Landscape', *Apollo*, vol.CXVII, no.259, Sept. 1983, pp.245–51

Kean, J., 'Johnny Warangula Tjupurrula: Painting in a Changing Landscape', *Art Bulletin of Victoria*, no.41, 2001, pp.47–54

Mackie, A., 'Fred Williams: An Australian's New Visions in the Landscape Genre', *Art International*, vol.XXIII, 5–6, September 1979, pp.13–18

Mackie, A., 'Fred Williams: Abstracted Landscapes', *Art and Australia*, vol.16, no.3, March 1979, pp.248–55

McCaughey, P., 'Fred Williams', *Art International*, vol.XVI, no. 9, Nov. 1972, pp.23–9

Mollison, J., 'Printmaking in Australia', *Art and Australia*, vol. 1, no. 4, Feb. 1964, pp.231–8

Plant, M., 'Melbourne Printmakers', *Art Bulletin of Victoria*, 1973–4, pp.27–34

Turner, J., 'Artists' Camp Erith Island: March 1974', *Overland*, no.60, Autumn 1975, pp.41–55

Wood, Lilian (compiler), 'Melbourne Printmaking in the 1950s – Personal Recollections Collated by Lilian Wood', *Imprint*, no.1, 1980, not paginated

Zdanowicz, I., 'Selected Affinities: Fred Williams's Drawings after Rembrandt', *Art Bulletin of Victoria*, no.29, 1989, pp.34–7